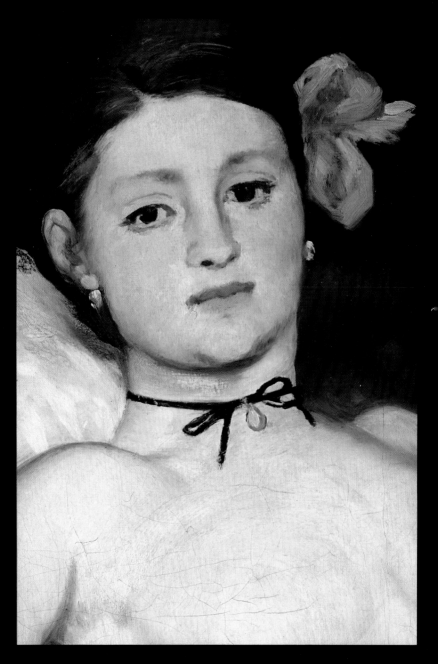

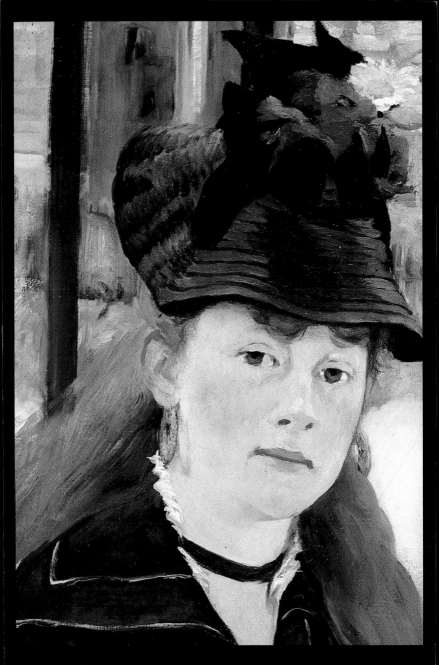

CONTENTS

MANET
THE INFLUENCE OF THE MODERN

Françoise Cachin

DISCOVERIES

HARRY N. ABRAMS, INC., PUBLISHERS

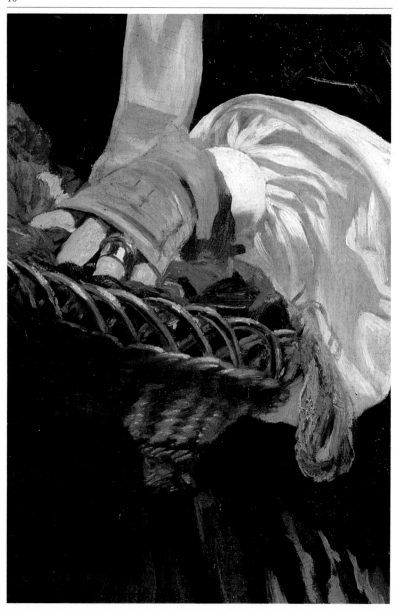

Was Manet the revolutionary artist, the inventor of pure painting that certain critics—most notably André Malraux—have dubbed him? Was he the destroyer of academism, or the person who revived great painting—the Titian, the Diego Velázquez, or the Frans Hals of his epoch? Was he a great blunderer, or the one who, inventing new methods, advanced the course of the great painting tradition? Was Manet the one who broke all the rules to become the first "modern," or was he, as Charles Baudelaire said, "the first in the decrepitude" of his art?

CHAPTER I
SCHOOLBOY, SEAMAN, ART STUDENT

In a detail of a portrait Manet made of his parents in 1860 (opposite), his mother's hand lies in a basket of wool. All her life, Manet's mother encouraged her son's unorthodox career. Right: A red-chalk drawing after a work by Andrea del Sarto.

There exists a question about whether or not artistic talent is genetic. "Art is a circle. Through an accident of birth one is either inside or outside it," Manet said, according to his friend Georges Jeanniot, implying that he was inside the magic circle of true artists by chance. In fact, Manet did not come from an artistic family, a circumstance contrary to that of most of the previous centuries' great painters. Manet was born into the middle class, and there he would remain. Still, he was destined to become the wisest kind of rebel: one who welcomes risks while preserving a fundamental regard for eternal values.

A Birth Near the Ecole des Beaux-Arts

Edouard Manet was born in Paris on 23 January 1832 at No. 5 Rue des Petits-Augustins (today's Rue Bonaparte), between the Ecole des Beaux-Arts and the Institute de France (headquarters of the Académie Royale de Peinture et de Sculpture), where all successful careers in painting were expected, on the one hand, to begin, and, on the other, to end. Manet, however, attended neither institution; indeed, all his life he would be regarded as their mortal enemy.

A week after his birth, Manet was baptized at the Church of Saint-Germain-des-Prés.

His father was a highly placed official at the Paris Ministry of Justice. As such, he belonged to the Parisian judicial bourgeoisie, with its strict standards of behavior, but he was also cultured and liberal-minded. Auguste Manet was descended from a long line of opponents to monarchy and empire and held strong republican convictions. Grandfather Fournier, on the maternal side of the family, had been a diplomat

Photographs of the young Manet (above) and his uncle (left), the jovial Captain Edouard Fournier, who, as a museum aficionado, played a major role in young Edouard's vocation.

The entrance to Manet's birthplace at No. 5 Rue Bonaparte.

This portrait of Auguste and Eugénie Manet was painted by their son in 1860. Auguste was ill at the time and would die two years later. He would not experience the satisfaction of seeing this work accepted at the Salon of 1861 and had no inkling of the rejections that his son would face during the career that began so auspiciously.

posted in Stockholm. While there he had enjoyed such favor from the king of Sweden that Manet's mother had been named the ruler's godchild.

As is often the case, Manet's early expressions of an artistic vocation ran contrary to his father's will—Manet *père* would have preferred his oldest son take up the family profession. It was a maternal uncle, Captain Edouard Fournier, who introduced the young Edouard to drawing and museums. Fournier regularly took the two older of the

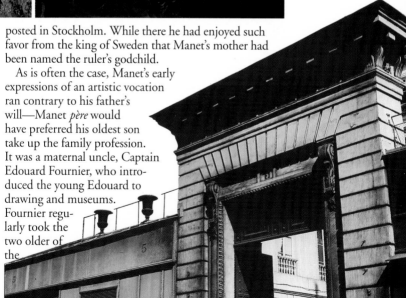

three Manet brothers (Eugène and Gustave were born in 1833 and 1835) to the Louvre. Edouard's classmate Antonin Proust—future minister of culture and publisher, after Manet's death, of his valuable memoirs of his childhood friend—also accompanied them on their outings.

Proust remembers Manet as being an indifferent student at their grammar school, the Collège Rollin, as well as rather insolent. He recalls that once, during a history lesson, their teacher asked the students to read philosopher Denis Diderot's

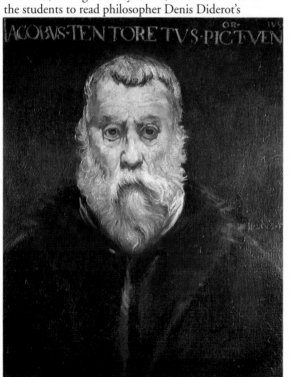

Between 1844 and 1848, Manet attended the Collège Rollin (today the Lycée Jacques Decour), on the Avenue Trudaine (above). Though Manet had been born on the Left Bank, his childhood was spent across the river in Paris's Batignolles section and in the neighborhood of the Saint-Lazare train station in the northwest, where he would later establish his studios.

For nearly ten years, Manet copied the masters, showing a clear predilection for Venetian painting. In 1854 he made this copy of Tintoretto's 1588 *Self-portrait* (left) at the Louvre, faithfully reproducing even the inscription at the top of the painting, which restoration work has since obliterated.

pioneering essays of art criticism, *Les Salons,* written between 1759 and 1779. "Concerning a reproach that Diderot had addressed to painters of his time for making hats …that were condemned to become outmoded: 'That is extremely stupid,' Manet exclaimed. 'One has to be in step with one's time, produce what one sees without worrying about fashion.'" Proust places this incident as having occurred around 1846–8; Manet was then about fifteen, and would have already been interested in painting.

A precocious talent for drawing and caricature made Manet embellish his school notebooks with small sketches, and, seeing these, his uncle Fournier offered to pay for elective courses in drawing. Manet's pencil was from the outset an instrument of rebellion; according to his cohort Proust, instead of "copying the helmeted heads of models, he penciled the heads of his fellow students." Did drawing and painting already embody for Manet his own form of opposition and liberation?

Copyists in the main gallery of the Louvre (above). The young woman on the tall stool appears to be making a miniature of the same self-portrait of Tintoretto. At the Louvre Manet made a number of the friends he would have all his life, among them Henri Fantin-Latour, Edgar Degas, and Berthe Morisot.

*En rade de Rio-Janeiro: à bord du
Havre-et Guadeloupe. ce 11 Mars 1849*

Manet the Midshipman

Regretfully, Manet's father began to renounce the idea of steering the poor student into a law career, but was, for the time being, adamantly opposed to the idea of his son becoming an artist. Did Manet himself, feeling the need to escape, propose the idea of becoming a sailor? However the situation came about, Manet took the entrance examination to the Ecole Navale in July 1848—but failed. It was decided that his apprenticeship had to follow another route, and in December of the same year, at sixteen years of age, Manet boarded the Rio de Janeiro–bound training ship *Le Havre et Guadeloupe* as an apprentice seaman. While this venture did not turn him into a sailor, these six months hardened the young Parisian and exposed him to the realities of life at sea and in the exotic ports of call he visited. In Rio de Janeiro the young man was not unaware of the Brazilian women, "generally very pretty; they have magnificent black eyes and similarly dark hair." And the black-skinned servant in his 1863 painting *Olympia* is perhaps reminiscent of a sight in Rio that struck him deeply: "I saw a slave market, it was a revolting spectacle; …the negresses are for the most part naked to the waist…. Some of them wear turbans, others arrange their kinky hair rather artistically, and almost all of them wear skirts bedecked with enormous flounces."

Manet fell in love with the sea, and he would vividly recollect it in his superb seascapes in the 1860s. "I learned a lot during my voyage to Brazil. How many nights did I spend gazing at the play of light and shadow in the ship's wake! During the day, from the upper bridge, my eyes never left the horizon line. That is how I learned the way to put down a sky," he is said to have told Charles Toché.

Guanabara Bay (the Bay of Rio) as the young Manet might have sighted it in 1849.

From an 1849 letter: "We were unable to find a drawing master in Rio; thus, our commander urged me to give lessons to my comrades…; it must be said that during the crossing I made myself such a reputation that each of the officers and teachers asked me for a likeness, and the commander even asked for his as a gift. I was delighted to fulfill all requests, in such a way that everyone was pleased."

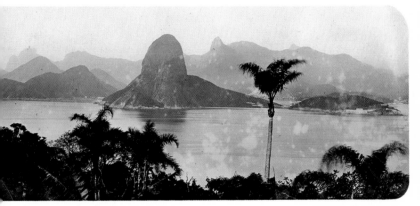

Couture's Studio

Back in Paris by June 1849, Manet again failed the entrance exam to the naval academy. This time his family at last consented to let him pursue an artistic career, his dream of so many years. Thus, in the fall of 1849, Manet joined the studio of historical and genre painter Thomas Couture, where he remained for six years and learned the business of painting. The choice of a master was well thought out: Having some years earlier been a winner of the coveted Prix de Rome

Manet described his apprenticeship and the sailor's life in an exotic port in affectionate letters to his parents.

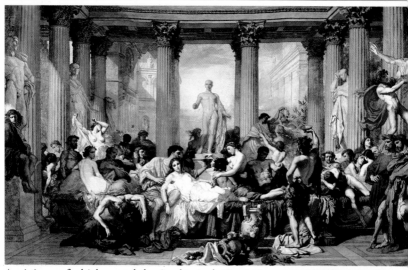

(recipients of which attend the Académie de France in Italy), at thirty-four, Couture was still a young fashionable painter, enjoying particular success with *Romans of the Decadence* at the Salon of 1847. Though a grand historical scene, the work was painted spiritedly in an informal composition and was not at all academic-seeming for the time—all aspects that no doubt attracted the young Manet.

The Couture studio was regarded as being among the most innovative. For learning painting, it was therefore a more daring choice, and was at first disapproved of by Manet's father, although in the end— showing himself to be more liberal than one might suppose—he respected the decisions of his seventeen-year-old son.

The years spent with Couture counted for a great deal more than modernist interpretations of his work—and Manet himself—would have one think. Couture's *Méthode et Entretiens d'Atelier*

(*Method and Discussions in the Studio*, 1867) shows what a fine and progressive teacher he was.

Manet evidently drew and painted a lot during the course of these six years. The notable absence of canvases from this period—apart from a few copies—leads us to believe that Manet later destroyed this part of his work, produced under the influence of another artist and later repudiated.

Jacques-Emile Blanche, a young apprentice painter who came to Manet's studio at the end of his life to watch the master at work, was astonished by his knowledge of his craft. "Manet was the last to paint surpassingly using methods and formulas that went back to the Spanish, the Flemish, and the Dutch." And, he astutely added, Manet, "probably the last to know how to handle the brush in a style that is in keeping with a magnificent tradition,

METHODE

ET

NTRETIENS D'ATELIER

PAR

THOMAS COUTURE

appears to have destroyed even the tradition of the decadents— I should say academic painters— who saw themselves as the classics, as the defenders of 'French taste.'"

When Manet did eventually rebel against his teacher, it was mostly against his objectives, the themes of his art. Couture was above all a history painter. For him, fine art consisted of narrative, allegory, and respect for the past. "On Mondays," recalls Proust, "the day when one set up the models' poses for the entire week, Manet had

Couture's large work *Romans of the Decadence* (1847, opposite above) was the artist's masterpiece. Today it is famous mainly for being an archetype of academic composition, created in an age of Courbet-style Realism. However, Couture's manner of painting and drawing was much freer than that of most other academic painters. Opposite below: A photograph of Couture and his signature.

Manet's drawing of a figure in Andrea del Sarto's *Baptism of Christ* in Florence.

run-ins with [Couture's] professional models…. Climbing up on their stand, they would assume their customary exaggerated poses…. 'Why can you not be more natural?' Manet would exclaim. [Answered the model,] 'It is hard to be so disdained by a young man like you!… Thanks to me, there is more than one work that has been sent on to Rome….'

[And Manet's usual response:] 'We are not in Rome! And we do not wish to go there. We are in Paris. We intend

to remain here.'" Another time, Manet had just succeeded in making a model adopt a simple pose and to remain partially clothed when, again according to Proust, Couture entered the studio. Seeing the clothed model, he made an angry gesture: "Who was responsible for this stupidity?" "It was me," said Manet. Upon hearing this, Couture supposedly answered him, "Come on, my poor boy, you will never be anything more than the [Honoré] Daumier of your time" (by which he meant a cartoonist, a realist, someone low in the artistic pecking order).

Manet made many copies—both painted and engraved (such as the one above)—of *Gathering of Thirteen Persons of Rank* (top), a painting erroneously believed to have been made by Velázquez. Also at the Louvre Manet copied Titian's *Jupiter and Antiope* (opposite).

The Museum as Studio

As much of Manet's education took place in the museums as it did in Couture's studio. First there was the Louvre, where he copied Italian works, including Tintoretto's *Self-portrait* (1588), two Titians—*The Virgin with Rabbit* and *Jupiter and Antiope* (1540)—François Boucher's *Diana at the Bath* (1742), Peter Paul Rubens' *Héléna Fourment and Her Children*, and an early 17th-century painting, *Gathering of Thirteen Persons of Rank*, which he presumed to have been made by Diego Velázquez (it is no longer attributed to the great Spanish artist). Manet also made several visits to museums in

Holland; his name is listed on the July 1852 register of visitors to Amsterdam's Rijksmuseum.

The following year had him making the traditional "grand tour" through Italy with his younger brother Eugène. In Venice and Florence the two Manet boys served as tour guides to Emile Ollivier, a future statesman in Louis-Napoléon's regime. In Florence Manet copied Titian's *Venus of Urbino*. (Ten years later, Manet would produce *Olympia*, which many saw as an irreverent version of this work.) According to Manet biographer Edmond Bazire, who came to know Manet

Emile Ollivier (top) was a young lawyer in 1853 when he met Eugène and Edouard Manet in Florence.

only shortly before his death —and who perhaps was able to glean anecdotes and information from the painter's wife—Manet also made a side trip to Germany and central Europe in 1853 on his way to Venice, visiting museums in Kassel, Dresden, Prague, Vienna, and Munich, where he copied a portrait by Rembrandt.

In 1857 the twenty-five-year-old made a second trip to Italy, this time staying primarily in Florence, where he copied the frescoes of Andrea del Sarto at the cloister of Sant' Annunziata.

Naturally, Manet admired a number of contemporary painters. Gustave Courbet, for one, whose *Burial at Ornans,* shown at the Salon of 1852 and reshown in 1855, had sparked intense discussions in the studios. "One doesn't know how to say how good it is because it is better than everything else," said Manet, according to Proust. "But between us, it is still not that. It is too dark." He also liked the work of certain landscape painters—a genre he himself never developed until late in life when he was forced to do so, "imprisoned" as he

Always copying the masters! A draped figure (above left) drawn in red chalk after a figure in Andrea del Sarto's *The Arrival of the Kings* (c. 1510) at the cloister of Sant' Annunziata.

This copy (above) of Delacroix's 1822 *The Barque of Dante,* made in 1854(?) while the painting was displayed in Paris, is the only known example of Manet's having copied the work of another living artist.

was in his garden by illness. Camille Corot, Charles-François Daubigny, and Johan Barthold Jongkind were, in Manet's estimation, "the strongest of the landscape painters."

Finally, there was, of course, Eugène Delacroix, whom Manet visited in 1855 to ask permission to copy *The Barque of Dante,* then on view at the Musée du

The contemporary modern masters most admired by Manet's generation were Eugène Delacroix (photograph left) and Gustave Courbet, of whom Manet would make this lithograph (bottom of page) from a photograph after the painter's death.

Luxembourg, the preeminent contemporary art museum of the period. The meeting was not a particularly warm one; in fact, Delacroix fails to mention it at all in his journal. Even so, in 1859 the master gallantly rose to Manet's defense when he was being painfully confronted for the first time by members of the implacable Salon jury, who would soon make him the most notorious of the Refusés.

"There is a masterful canvas at the [Musée de] Luxembourg, *The Barque of Dante,*' [Manet exclaimed one day]. 'If we went to see Delacroix, we could use as our pretext our desire to ask his permission to make a copy of the work.' 'Take care,' Murger told us, when Manet told him of our plan at lunch. 'Delacroix is cold.' In fact, Delacroix received us with perfect charm in his studio at Notre-Dame-de-Lorette, questioning us about our preferences and telling us of his…. When the door was shut behind us, Manet said to me: 'It is not Delacroix who is cold; it is his doctrine that is passionless. Nevertheless, let's copy *The Barque.* It is quite a piece!'"
Antonin Proust, 1897

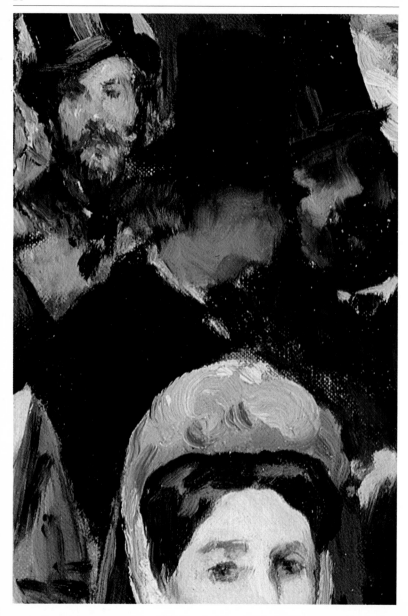

"Re-creating historical figures, what a fine joke! There is only one authentic thing: to paint directly what you see. When you've hit it, you've really hit it. When you haven't, you start over. All the rest is humbug."

Manet (as reported by Antonin Proust)

CHAPTER II
BAUDELAIRE AND SPAIN

Mme. Lejosne gazes from beneath the large blue brim of her hat (opposite, detail from *Music in the Tuileries*, 1862). Manet met poet and art critic Charles Baudelaire (visible just above Mme. Lejosne, in profile) at her home. The bearded man behind Baudelaire is the painter Henri Fantin-Latour. Right: *The Exotic Flower*, an etching done in the Spanish manner by Manet, in a style reminiscent of Francisco Goya.

The confidence of the young art student from Couture's studio, his aplomb and his easy banter, made him an extremely popular figure, even before he had produced a single work of note. He and classmate Albert de Balleroy were soon ensconced in their own studio.

When Manet left Couture's atelier in 1856, already enveloped in this aura of a revolutionary—which earned him the admiration of the youth of his time—he did not hurry to exhibit. "Before taking on the salons, I must first call on the Old Masters," he said. In fact, until 1859, Manet continued to make his copies—of Tintoretto, Velázquez, and Rubens—at the Louvre, where he met Henri Fantin-Latour and Edgar Degas, who were soon to become his closest painter friends.

Manet wanted to show his first work at the Salon of 1859, *The Absinthe Drinker*. It turned out to be his first rejection and his first scandal, but in a way also his first success: His budding talent was quickly defended by Delacroix, an important member of the jury, and by Baudelaire, a key figure in Paris's literary and artistic circles.

Apart from the deliberately sketchy style, the nonchalant work was preordained to displease the jury, since Manet's choice of subject was a drunk next to his bottle. The work was in no way allegorical, but in fact very real—the model was a known figure named Collardet—and was in itself a declaration of principle, and perhaps also a defense and illustration of Baudelaire's poems about wine, hashish, and the somber grandeur of the down-and-out bohemian character.

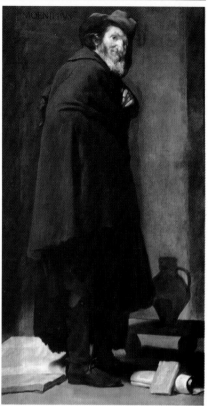

Even before his trip to Spain, the influence of Velázquez—who was known widely because of his engravings—on Manet is evident. Above: Velázquez's *Menippus* and *The Philosopher*, an engraving by Manet.

Opposite below: Detail from an article about the 1859 Salon, with a preface by George Sand.

Baudelaire and Manet

Manet was well acquainted with Baudelaire. As a young man, he had likely visited with him at the home of Commandant Lejosne, a friend of the Manet family who played host to a wide variety of people, including the Manets, the critic Barbey d'Aurevilly, the illustrator Constantin Guys, the engraver Félix Bracquemond, and the photographer Nadar (whose real name was Gaspard-Félix Tournachon). By 1859 the

Manet's *The Absinthe Drinker* (1858–9, above) was his first truly realistic work, and in making it he employed an aggressively sketchy technique, on both counts clearly breaking away from his classical training. Baudelaire's words were likely the inspiration for this image of the philosopher-drunk, a sort of Edgar Allan Poe of the Paris streets.

young painter and poet were already intimates.

"We were seated at his home with Baudelaire, when the news of the refusal arrived; a discussion on Couture and Delacroix soon followed…: 'The upshot,' said Baudelaire, 'is that one must be oneself.' 'I always told you that, my dear Baudelaire,' retorted Manet, 'and was I not myself in *The Absinthe Drinker*?' 'Aha! Aha,' countered Baudelaire. 'Come on, there is Baudelaire who is going to malign me! Everyone then….'" This discussion, recalled by Antonin Proust, shows us that Manet had a friendly supporter in Baudelaire, though the poet/critic was not completely without reservations. Baudelaire never wrote publicly to defend the painter. However, after 1859 Baudelaire did not publish reviews of any of the Salons, and each time the occasion arose he did support Manet in his own way. Perhaps the poet felt that Manet lacked the one thing that Baudelaire regarded as preeminent among the faculties: imagination. Or did he reproach his friend for what he considered to be a serious character flaw: the pursuit of success? But Manet knew very

The glass of absinthe in *The Absinthe Drinker*, an image suggestive of the drunken excesses of a Baudelairean "ragman-poet."

P. NADAR

Nadar 20541- Manet PARIS

Baudelaire and Manet photographed by their mutual friend Nadar. Baudelaire's illness and, finally, his death in 1863—when Manet was only thirty-one—robbed the painter of an old friend and supporter. Had he lived, it would surely have been he, rather than Constantin Guys, who would have hailed him as "the painter of modern life."

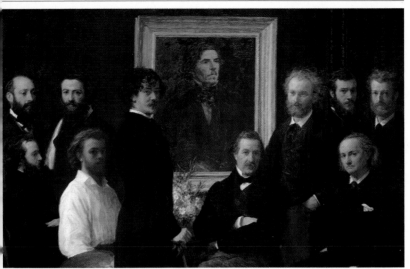

well that Baudelaire was fond of him and admired his qualities as a painter. "There are flaws, shortcomings, a lack of aplomb, but there is also an irresistible charm. I know all that, I am one of the first who understood it," the poet wrote in 1865. Furthermore, he cited Manet in his last published piece of art criticism, about an 1862 exhibition of etchings: "At the next Salon we will see several works imbued with a strong Spanish flavor, which would lead one to believe that the Spanish virtuosity has taken refuge in France. Messieurs Manet and [Alphonse] Legros are united in their decided preference for modern reality—which is already a good sign—this vivid and expansive imagination, sensitive, bold, without which, it must be said, even the best talents are only servants without a master."

Under the Spell of Spain

Romantic literature, from the novels of Victor Hugo to the poems of Théophile Gautier—had made Spain fashionable in the late 19th century. One can also see, in the texts of Baudelaire, for instance, that Spain was being associated with Realism. For the young painter, the "Golden Age of Iberia" represented an opposing view to the classical models of antiquity

Fantin-Latour painted this *Homage to Delacroix* (1864, above). He presents himself in a white shirt, seated behind the elegant American painter James Abbott McNeill Whistler, who, with Manet, frames Delacroix's portrait. To Manet's right are his friends Balleroy, Bracquemond, and Baudelaire (seated).

and Italy so extolled by the Académie.

The whole philosophy of sublime rags, of the beggar-saint, in which Romanticism and Realism were happily blended, soon was to inspire Manet's *guitarreros*, pensive as poets (*The Spanish Singer*, 1860), his costumed children, charming and authentic as Sevillian *niños* (*Boy with Dog*, 1860–1) and gracious as princes (*Boy with a Sword*, 1861), and his dancers proud as duchesses (*Lola de Valence*, 1862).

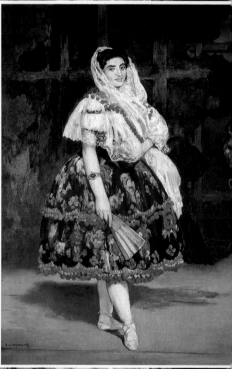

Surprisingly, before 1865, Manet had never been to Spain, and after his return he no longer painted "Spanish subjects," apart from one bullfight scene, which he did from memory. But his ultimate hero would always be Velázquez. This he knew even before his trip, though he could only really study the master's works in all their

splendor in Madrid, at the Museo del Prado—as is still the case today.

"What captivated me most about Spain, what alone was worth the trip, was Velázquez. He is the painters' painter.... The sight of these masterpieces gave me great hope and confidence," Manet wrote to his friend the art critic Zacharie Astruc in September 1865. The painter's

predilection for the Spanish school earned him his first major success in May 1861. *The Spanish Singer* was admitted to the Salon, as was the *Portrait of M. and Mme. Auguste Manet*, and he was rewarded with an honorable mention and a laudatory review by Gautier. For the first time, Manet's forthright and energetic technique and his sense of color, set off by his use of black, were recognized. He himself said that in painting *The Spanish Singer*, he was thinking "of the masters from Madrid and also of [17th-century Dutch master Frans]

L*ola de Valence* (1862, opposite, whole painting and details) and *The Spanish Singer* (1860, left) enchanted Baudelaire and Gautier.

"Among all the beauties that are to be seen I understand, friends, Desire chooses with pain But one may see sparkling in Lola of Spain The unforeseen charm of black-rose opaline."
Charles Baudelaire

"*Caramba!* Here is a *guitarrero* who doesn't come from the Opéra Comique.... Velázquez would have greeted him with a friendly wink, and Goya would have asked him for a light for his *papelito*.... There is a lot of talent in this figure with its unaffected grandeur, painted with a bold brush, and in very authentic color."
Théophile Gautier

Hals." Manet felt a strong association between the painter of Haarlem and Spain: "I cannot get out of my head," he said, "that Frans Hals must have been of Spanish descent. There would be nothing surprising about that. He was from Mechelen" (a city occupied by Spain in the 16th century).

With this first success, a small admiring coterie formed around Manet. He must have thought—for an instant at least—that he had attained lasting glory, no doubt making it all the more difficult to bear his repeated failures at the Salon over the ensuing twenty years.

From the Café Tortoni to the Tuileries Gardens

For the moment, however, Manet was in fashion as he went about leading the life of a bohemian dandy. "He went almost daily to the Tuileries from two o'clock to four o'clock, doing studies *en plein air,* under the trees, of children playing and groups of nursemaids relaxing on chairs. Baudelaire was his usual companion. People watched with curiosity as this fashionably dressed painter set up his canvas, took up brush and palette, and painted with as much composure as if he were in his own studio." Proust's words, written at the end of the century with the conscious aim of making Manet appear to be the father of Impressionism, lead one to believe that Manet executed his paintings outdoors. Such was not the case, however; Manet did make small sketches outdoors, but he painted only in his studio.

"The Café Tortoni was the restaurant where he lunched before going to the Tuileries, and, on his return between five to six o'clock, where he would accept compliments on his sketches as they passed from hand to hand," Proust recalled. "But [those from] the Butte Montmartre and the other side of the water stood watch, and the old saying that one has more to fear from one's friends than one's enemies was to come true for him. He was wined and dined at the Café Guerbois and at the brasserie on the Rue Hautefeuille [Courbet's haunt], but he was also envied. 'This young man mustn't pretend to be another

On the Boulevard des Italiens, the terrace of the Café Tortoni, a popular gathering place among the elegant bohemians of mid-19th-century Paris.

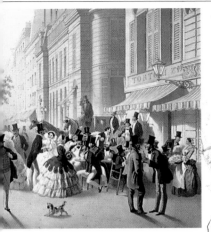

Velázquez,' said Courbet. The convention-bound [the academic painters] rubbed their hands with glee to see that division ruled among the intransigents."

In reality, nothing was further removed from Courbet's universe than the elegant, worldly bohemia in which Manet naturally flourished. *Music in the Tuileries* (1862) showed this society in crinolines and top hats, under natural light in the emperor's garden where concerts were given twice a week. The work seems to have been at least partially inspired by Baudelaire, who, ever since the Salon of 1846, had been urging artists to paint "the heroism of modern life" and "the spectacle of urbane existence." But Manet's elliptical technique, and his deliberate retention of a certain sketchy quality taken from life itself, failed to please; critics of the period reproached him for "scorching the eye as fairground music assaults the ear," and for his "mania of seeing things as patches." Today it is easy to imagine what younger artists like Frédéric

This India-ink drawing of a nook in the Tuileries (opposite) was made by Manet on the spot in one of his notebooks. Another sketch in the same notebook shows the face of the opera composer Jacques Offenbach (above) and the curve of one of the garden's chairs.

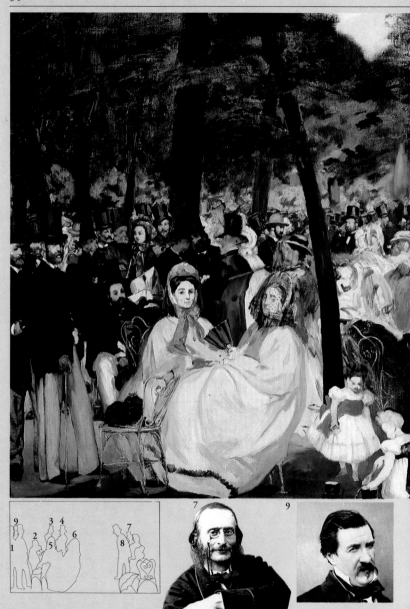

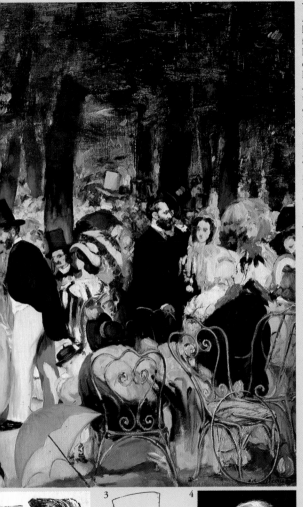

In *Music in the Tuileries* (1862), Manet amused himself by gathering his friends around him. He himself can be seen in his elegant beard at the far left (1). Next, Zacharie Astruc (2), seated under a tree, and Baudelaire (3) chatting casually with Baron Isidore-Justin-Séverin Taylor (4), a passionate promoter of Spanish art in France. The women seated in the foreground are Madame Lejosne (5) and Madame Offenbach (6), whose mustachioed husband, Jacques (7)—soon to become renowned for his operas *La Belle Hélène* and *La Vie Parisienne*—is sitting under the tree at right. Just in front of him is Eugène Manet (8), standing, slightly stooped. (This younger brother of Manet later married the painter Berthe Morisot.) The person to the right of Manet, at the extreme left of the painting, may be the critic Champfleury (9). The painting was likely inspired by Baudelaire, who wrote, "For the consummate stroller, for the passionate observer, it is an immense pleasure to be among the multitude, to enter into the ebb and flow, the moving, the transitory, and the boundless."

3

4

Bazille, Claude Monet, and Auguste Renoir must have discovered in this work, which—even more than *Le Déjeuner sur l'Herbe*—was a catalyst for the Impressionist movement.

Where Nymphs Were Hidden and Children Disguised

If the Tuileries presented a spectacle of modern public life, several of

Manet's works from 1859 to 1861 revealed his clandestine private life while masquerading as Spanish- and Flemish-inspired works. Such was the case with *The Surprised Nymph* (1859–61)—which in fact was originally a section of a much larger work entitled

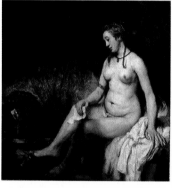

The Finding of Moses. Manet probably separated it either because he felt he had failed to master his first very ambitious composition, or because he found the large canvas to be too much in keeping with the history paintings that he had hitherto scorned.

The model for the pharaoh's daughter, transformed into a modest and voluptuous bather, was none other than the woman who had been Manet's companion for the previous six years, Suzanne Leenhoff, whom he had met in 1849 when she was giving piano lessons to his younger brothers. At the time, Manet was only seventeen years old, and she, two years older. In

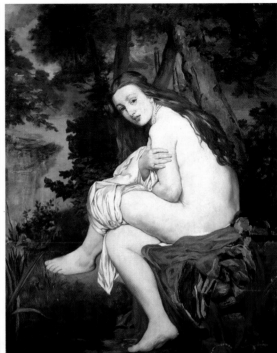

January 1852 Suzanne gave birth to a son, Léon-Edouard Leenhoff, and it is widely accepted that the young Edouard Manet was his father, even though the painter never officially acknowledged it, not even in conversation with his closest friends.

Suzanne, who posed altogether nude for *The Surprised Nymph*, resembles an opulent fruit, a cross between Rembrandt's *Bathsheba* and Boucher's *Diana at the Bath*, figures from two paintings that had recently entered the Louvre's collections and which Manet had

The Surprised Nymph (1859–61), was a tribute to other painted bathers, including Rembrandt's *Bathsheba* (1654, opposite center) —which Manet had studied in the La Caze collection—and François Boucher's *Diana at the Bath* (1742, opposite below). Manet cut apart his much larger original work, *The Finding of Moses*, to focus the composition on the nude, for which his companion, Suzanne, posed.

studied at great length. In this painting, so reminiscent of the Northern school, he transfigured his Dutch companion. In another painting, *The Catch,* Manet depicted his clandestine relationship with Suzanne, disguising himself as Rubens and Suzanne as the painter's wife, Hélèna

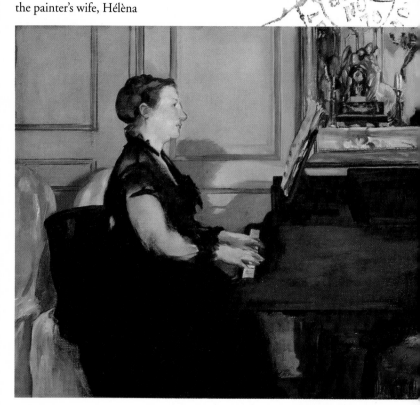

Fourment. Léon is visible in the middle distance, fishing from the shore.

Suzanne: Beaming Good Nature

Manet married Suzanne a year after his father's death in October 1863, and, despite his antics, he remained very

Mme. Manet at the Piano, painted in 1867–8 by Manet in his mother's apartment, where he and his wife lived. Opposite: A photograph of Suzanne Manet.

close to her throughout their life together. Her good sense, her kindness, her gaiety, and her talent as a musician—an

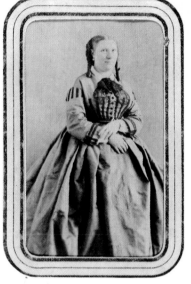

excellent pianist, Suzanne kept abreast of contemporary music, even playing Wagner at the hospice where Baudelaire lay dying—all of these qualities were an undeniable source of stability for Manet. His letters to Suzanne when they were separated during the 1870 siege of Paris by the Prussians are proof, as are several portraits he made of her—her peaceful face and demonstration of her gifts as a pianist in *Mme. Manet at the Piano* (1867–8) or the maternal solicitude apparent in her attentive listening in *Reading*. Without ever flattering her, he extolled her generous corpulence—"the buxom Suzanne" is what Berthe Morisot would later call her.

The painter Giuseppe de Nittis, who knew Suzanne well, recalled that "Madame Manet had something about her that was rather singular: a graceful kindness, a simplicity, a candor of mind—a serenity that nothing could alter. One felt, in her slightest words, the profound passion she had for her charming *enfant terrible* of a husband…. One day, he was following a pretty girl, slender and flirtatious. Suddenly, his wife caught up with him and said with a hearty laugh, 'This time, I've caught you at it!' 'That's funny,' Manet responded. 'I thought it was you.' Now, Madame Manet, a placid Dutchwoman and a little on the hefty side, had nothing in common with a frail Parisian coquette. She recounted this anecdote herself with her beaming good humor."

Manet's relationship with Léon was more mysterious. It may be understandable that, during the first ten years of his relationship with Suzanne, Manet would have wanted to keep his liaison with Suzanne and the presence

"It would appear that his wife is very beautiful, very good, and very artistic," Baudelaire wrote when learning of the marriage. "So many treasures in a single female, isn't it monstrous?" During the Prussians' siege of Paris in 1870, Manet sent Suzanne letters filled with tenderness.

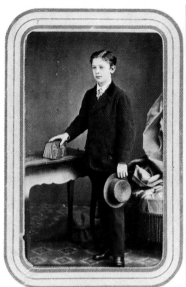

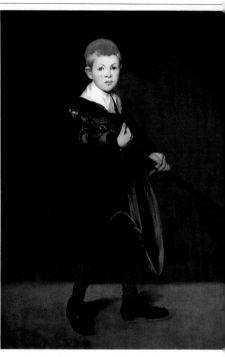

of the child hidden from his family. But in view of the obvious affection between mother and daughter-in-law —the "Manet women"—why did he continue to hide his paternity after his father's death, and indeed, until the end of his life? It is quite possible, of course, that a slight doubt about his paternity persisted. In any event, Manet raised Léon—who called him "godfather"—as his son.

Léon posed often for Manet during the 1860s. He was the carrot-topped youngster in a black velvet outfit, rather overcome by his weapon in *Boy with a Sword* (1861), the youngster in *Soap Bubbles* (1867), and, most prominently, the enigmatic adolescent in the foreground of *The Luncheon* (1868), whose vacant, sulky expression left no hint of the true relationship between painter and model, except a sort of reciprocal perplexity.

The Arrival of Victorine

Fashionable society shown as it truly was, the family presented in disguise—these were not the only

The young Léon Leenhoff in a photograph and as a Spanish page in Manet's *Boy with a Sword* (1861).

> "It is said that Edouard Manet had some affinity with the Spanish masters, and it was never more apparent than in *Boy with a Sword*."
>
> Emile Zola

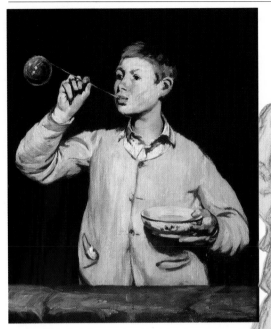

subjects that Manet treated at the start of the extraordinarily productive 1860s. The other side of Baudelaire's stipulations on painting found in his *L'Héroïsme de la Vie Moderne* (*The Heroism of Modern Life*), in which he wrote about the "milieu of ephemeral existences floating through the labyrinths of a big city," Manet showed through a whole series of pictures of wanderers, displaced persons, and clowns. These works included *The Street Singer* and *The Old Musician,* painted the same year as *Music in the Tuileries,* and the series of musicians and Spanish dancers on tour in Paris—of which Lola de Valence, thanks to Manet's painting of the same name, has remained the most famous—as well as several drawings and engravings. *The Bear Trainer, The Clowns,* and *The Gypsies* also demonstrated this search for new themes.

The Old Musician was Manet's most ambitious composition. More than eight feet wide and six feet high, it is painted in a realistic style that thrust him into

At age fifteen, Léon posed for *Soap Bubbles* (1867), a traditional allegory about the precariousness of life. Above is a sketch of the young man a year later, at about the time Manet made his most beautiful portrait of him, in the foreground of *The Luncheon.*

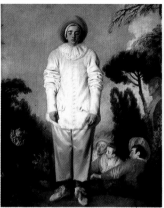

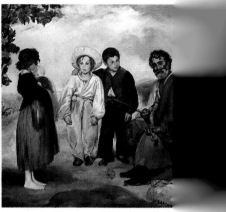

competition with not only Courbet and Velázquez, but even the brothers Le Nain of the early 17th century, whose popularity the critic Champfleury (Jules Husson) had just revived among the avant-garde.

Less spectacular perhaps, though no less gripping, was the reproduction of an encounter Manet had while wandering through a section of Little Poland, near his studio: "At the entrance to the Rue Guyot," Proust recalls, "a woman was coming out of a seedy cabaret, one hand holding up her dress, in the other, a guitar. [Manet] went straight up to her and asked her to pose for him. She began to laugh. 'I'll catch her again,' Manet cried out, 'and then if she still doesn't want to, I've got Victorine.'"

Victorine Meurent —who, in fact, did ultimately pose for *The*

Close-ups ⟨ Meurent' face and brilli (below).

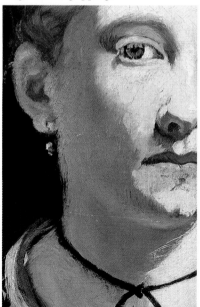

Street Singer—had by this time become a fixture in Manet's life. She had already posed for *Mlle. V… in the Costume of an Espada* (1862) and for a portrait of a young redhead with a starkly lit face. The remarkable Victorine was to become Manet's mascot, his accomplice in the scandals ahead. The patience with which she posed, her relaxed charm and gaiety, her

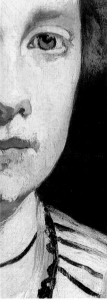

freedom in love, her independence, and her lack of shame, contributed greatly to the uproar set off by two paintings that were soon to make Manet the hero of the day: *The Bath* (known later as *Le Déjeuner sur l'Herbe*) and, of course, *Olympia*.

In *The Old Musician* (1862, opposite right), Manet created a rather bizarre and anomalous grouping, associating it perhaps with certain figures he had already painted, such as *The Absinthe Drinker*, as well as with others at the Louvre. The little boy in white recalls Jean-Antoine Watteau's *Gilles* (c. 1719, opposite left). The central musician resembles a Hellenistic sculpture of the 3rd-century BC philosopher Chrysippus, which Manet had sketched at the Louvre (left). The little gypsy in the foreground was taken from *The Stolen Child*, a work by Schlesinger shown at the Salon of 1861. As for the old Jewish man at the painting's extreme right, he was a popular model whose address was later discovered in one of Manet's notebooks.

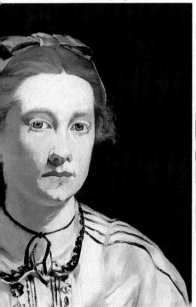

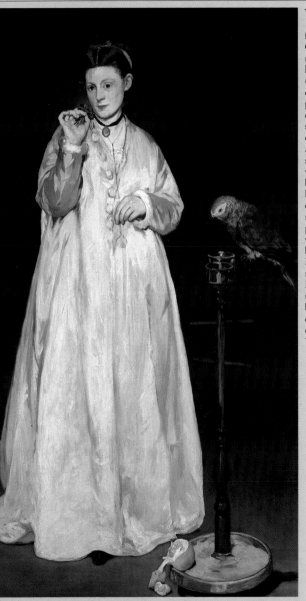

Victorine adopted many different roles for Manet's compositions. One of the most famous naked women in the history of painting is here (opposite) very much dressed, disguised as a poor street singer, eating cherries at the cabaret's stage door. In the elegant déshabillé of *Woman with a Parrot* (1866, left), she sniffs a small bouquet of violets with a pensive and becoming air. Courbet had shown at the Salon of the same year a superb reclining nude woman playing with a parrot, a work that might have been made in response to Manet's *Olympia*. It is not impossible that Manet then appropriated the woman-bird theme, but this time completely clothing the subject of his earlier scandalous work.

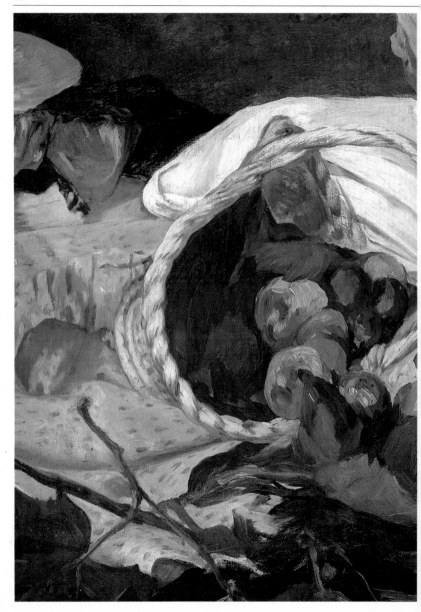

History has endowed certain paintings with the signal status of inaugurating a new chapter in art. There is a before and an after. This is the case for Picasso's *Les Demoiselles d'Avignon* in the 20th century; and, in the second half of the 19th century, rightly or wrongly, the same role was fulfilled by *Le Déjeuner sur l'Herbe*.

CHAPTER III
"IS THIS PAINTING?"

In the foreground of *The Bath* (1863, detail opposite), more famous now under the title *Le Déjeuner sur l'Herbe*, Manet painted a superb still life: a basket of fruit carelessly overturned on the model's garments. At left is one of Manet's numerous pen-and-ink portraits of cats, animals for which Manet and Baudelaire shared a great fondness.

On 15 May 1863 the Salon des Refusés opened in an annex of the official Salon, which was held in the Palais de l'Industrie (also called the Palais des Champs-Elysées). Two nudes shown in the official Salon captivated the public and the critics: Paul Baudry's *The Pearl and the Wave* and Alexandre Cabanel's *The Birth of Venus,* which was immediately purchased by Emperor Louis-Napoleon. But in the Salon des Refusés the curious public could view those scandalous avant-garde works that had been rejected by the official Salon.

CATALOGUE
DES OUVRAGES
DE
PEINTURE, SCULPTURE, GRAVURE
LITHOGRAPHIE ET ARCHITECTURE
REFUSÉS PAR LE JURY DE 1863
Et exposés,
par décision de S. M. l'Empereur,
AU SALON ANNEXE
PALAIS DES CHAMPS-ÉLYSÉES

As many as seven thousand people visited the exciting and diverting Salon des Refusés on opening day. "The exhibition was separated from the other by a turnstile. One entered as if one were entering the 'Chamber of Horrors' at Madame Tussaud's in London," recalled Jean-Charles Cazin, one of the Refusés. It is hard to comprehend today that works by such artists as Whistler, Cézanne, and Fantin-Latour—all of which have since become respected and beloved—could have at one time fomented such mirth. Of course, this is also the case for the paintings of the young Manet.

Corrupt Taste

It was Manet, in fact, who proved the hero of the day with his contribution—a sort of triptych, whose central panel, *The Bath* (later renamed *Le Déjeuner sur*

"MY SON! TAKE OFF YOUR HAT! LET US HONOR UNHAPPY COURAGE."

l'Herbe), was flanked by *Young Man in the Costume of a Majo* and *Mlle. V… in the Costume of an Espada*. Most critics were shocked, not just by the subject matter, but also by the technique. "Manet will have talent the day he learns drawing and perspective, and he will have taste the day he gives up choosing subjects solely for their ability to create a scandal," noted critic Ernest Chesneau.

"We cannot accept that this is a perfectly chaste work of a young woman seated in the woods dressed only in

The 1863 Salon des Refusés gave rise to many caricatures, such as this one (left) by the satirist Cham.

Opposite: The cover of the small catalogue published for the 1863 Salon des Refusés.

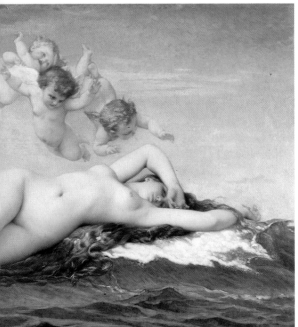

One need only compare *Le Déjeuner sur l'Herbe* and the *Olympia*, painted the same year, to Alexandre Cabanel's *The Birth of Venus* (left)—a great success at the official Salon of 1863—to understand why it is that Manet's nudes were so shocking but those of the academic painters (even though they were more lascivious and, one might say, hypocritically sluttish) were not. Cabanel's Venus is idealized, but in keeping with the taste of the day, and she modestly hides her face. Cupids flying above her indicate that this is a goddess, not a woman of the 1800s. She is painted in a smooth and sugary manner—"in exquisite taste," according to the same critic who found Manet's nudes so vulgar and his manner of painting so brutal.

the shade of leaves and surrounded by [male] students wearing berets and overcoats," he continued. "That is a very secondary consideration, and I deplore, even more than the composition itself, the intention that inspired it…. M. Manet wants to achieve fame by shocking the bourgeois;…his taste has been corrupted by his fascination with the bizarre." Added Jules-Antoine Castagnary, "I agree that *The Bath, The Majo,* and *The Espada* are good rough sketches. There is a certain life in the tone, a particular honesty in the brush stroke, both of which are far from average. But beyond that? Is this drawing? Is this painting? M. Manet thinks he is solid and powerful, he is only hard; what is especially odd is that he is weak as well as hard." Even a critic as discerning as Théophile Thoré found *The Bath* to be "in slightly risqué taste," though he also noted that "in these spurned works there appears to be a new beginning for French art. He is baroque and wild, sometimes apt and even profound."

From *Le Déjeuner sur l'Herbe…*

The centerpiece of the triptych, positioned between two brilliant works of Spanish fantasy, was altogether classic in inspiration. Connoisseurs, artists in particular, could not have missed that. In fact, its group of three figures had been copied from an early 16th-century composition of Raphael's, *The Judgment of Paris,* which had been popularized by a contemporary, the engraver Marcantonio Raimondi. This view of two river gods and a nymph was well known in the studios of Manet's day. The only difference in Manet's work was that, while leaving the woman naked, he had dressed the two men in contemporary garb, making their companion an "authentic" modern nude, a woman undressed, whose clothes could be seen brazenly strewn in the foreground among the remains of a picnic.

Two works done in the "Spanish manner" flanked *The Bath* at the Salon des Refusés in 1863. On the left was *The Young Man in the Costume of a Majo* (above), for which Manet's brother Gustave posed. Critics deplored the vividness with which the red blanket had been painted, remarking that in this work, as well as the one next to it, the head ought to be painted "differently than the fabrics, with more intensity and profundity" (Thoré).

It must be said that Titian's *Concert Champêtre* (c. 1508, then falsely attributed to Giorgione), one of the Louvre's most famous paintings, contains nothing different from what is depicted in Manet's notorious work. It is simply that no one was shocked any longer by the sight of young musicians dressed in the clothes of Titian's time next to a nude woman. In truth, Manet— though no doubt fully aware of the provocativeness of the canvas that he himself called the *La Partie Carrée* (*The Party of Four*) —had done nothing more than the work of a contemporary Titian. The allusion was clear, and perhaps more than the naturalistic nudity of the model or the sketchy, if not downright hasty, style of the landscape—a deliberately offhand-seeming backdrop behind models who clearly had posed in the studio—the real scandal was this placid challenge to high art. Manet was, in fact, measuring himself against the great Spanish and Italian masters of the 16th and 17th centuries, not against those who were winning the Académie's prizes in his own time, not even against Courbet, whose work he had obviously consciously drawn upon in painting his nude and the still-life in the foreground.

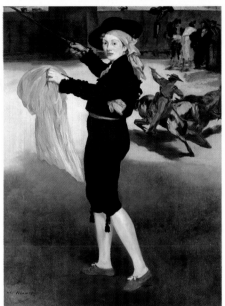

H ere, gazing at us when she should be looking at the bull, is Victorine Meurent, disguised as a bullfighter. This context only served to heighten the model's femininity. "An unusual costume and an unusual occupation for a young person," wrote a journalist for the French publication *Le Siècle*. "I confess that I'd rather see her pursue more tender conquests and…if I had to choose a companion, [between one who] excelled at making jam and the other at killing bulls, it is the first I would pick!"

…To Impressionism

Many people have wanted to detect *a posteriori* in this scene of a nude under the trees the first manifestation of Impressionism. Manet himself changed the title of the work for his private exhibition of 1867 only after Monet had entered the fray with his own "déjeuner sur l'herbe" (*The Picnic*, 1865–6), only this time, one that truly was painted out-of-doors, at Fontainebleau. Did Manet sense the extraordinary innovation in Monet's work and want

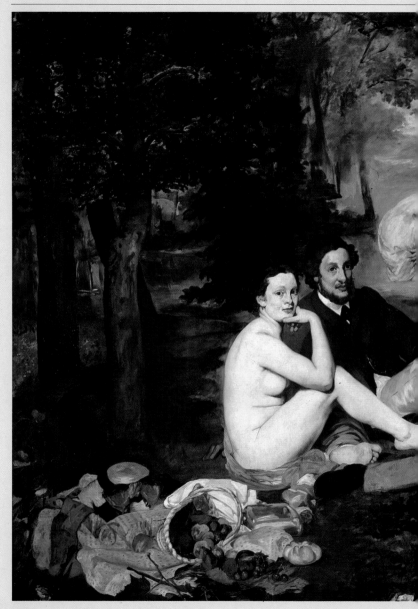

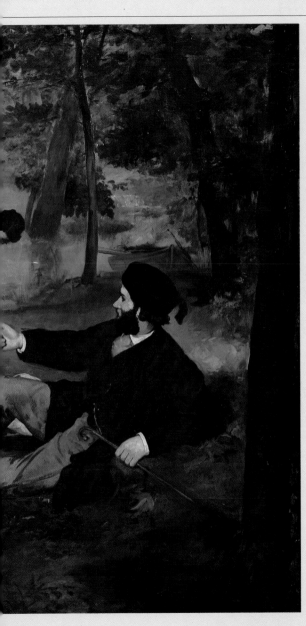

"My God! What indecency: a woman without the least covering between two clothed men!... The crowd... thought that the artist had instilled an indecent and disturbing design in the arrangement of his subjects, when, in fact, he only had sought to obtain lively contrasts and authentic masses.... What must be seen in this painting is not that it is a picnic, but that it is an entire landscape, with its strengths and its subtleties, its foreground so large and solid and its background so light and delicate; it is firm flesh modeled with great patches of light..., this corner of nature rendered with such fitting simplicity."

"You needed a nude woman, and you chose *Olympia* [overleaf], the first one who showed up; you needed light and brilliant areas, so you put in a bouquet; you needed dark areas, so you put in a negress and a cat. What does all of this mean? You don't know, nor do I. But I know that you have succeeded in making a work of art, the work of a great painter, in other words, to render energetically and in a unique language the verities of light and shade, the realities of objects and creatures."
Emile Zola, 1867

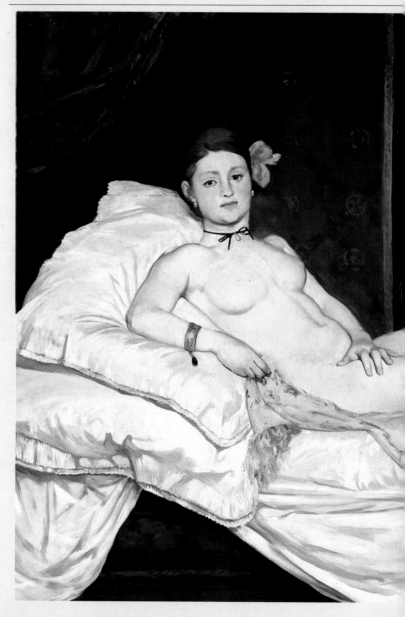

Olympia
La fille des Îles

to impress on others the fact that it was he who was the progenitor of this "new painting" and that he intended it to remain that way? The more or less conscious strategy that Manet pursued throughout his entire career could lead us to think that.

But in reality, Manet's truly representative modern work, much more so than *Le Déjeuner sur l'Herbe,* was his *Olympia*—also painted in 1863, though not exhibited until two years later.

Victorine as Olympia

This odalisque (concubine), this harem creature (whose profession was unmistakable to the public at the time), was an agglomeration of Manet's most cherished paintings: a modern and ironic reincarnation of Titian's *Venus of Urbino,* which he had copied at the Louvre, Francisco Goya's *Nude Maja,* and Jean-Auguste-Dominique Ingres'

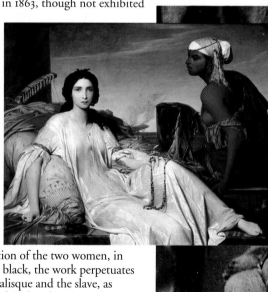

Odalisque. In the juxtaposition of the two women, in this case one white and one black, the work perpetuates the long tradition of the odalisque and the slave, as did various works being exhibited at the Musée du Luxembourg at the time.

But Manet added to this altogether honorable genealogy the quiet impudence of Victorine, truly a

In 1863 Manet transposed this painting (left), his copy of Titian's *Venus of Urbino*, into the *Olympia*. This 1853 photograph (below) toys with the fashionable eroticism of the contrast of white flesh and black flesh, so refined in Jean-Achille Bénouville's 1844 *Odalisque* (opposite left).

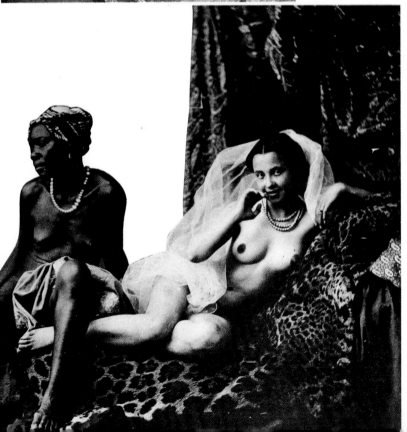

"free bohemian, a painter's model, a hedonist of the brasserie, a paramour for a day…with a cruel child's face and eyes of mystery" (critic Gustave Geffroy).

The black cat with raised tail gave the work a note of erotic irony; with a sly wink to the art student, Manet substituted for the faithful dog sleeping at the chaste feet of the *Venus of Urbino* an animal that was believed to be satanic. Moreover, "cat" in French slang is the word for the very thing Olympia is concealing with her hand. Perhaps Baudelaire had also inspired him: "I should have wished to live with some young giantess / As at the feet of a queen, a voluptuous cat."

Manet was by no means unaware of all that was embodied in his black cat. Indeed, X rays have revealed that the animal was painted in as an afterthought, most likely shortly before it was submitted to the Salon of 1865—more than a year after the rest of the canvas was completed. This detail alone does much to show how ambivalent Manet was. On the one hand, he was completely devastated by the scandal his work provoked—a reaction attested to by both friends and critics —and, on the other,

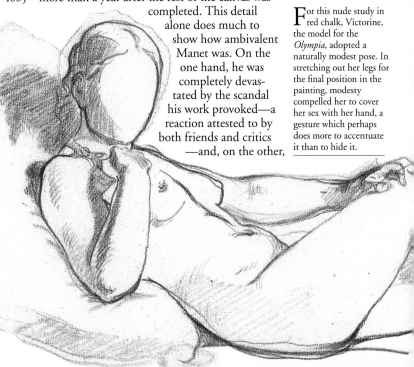

For this nude study in red chalk, Victorine, the model for the *Olympia*, adopted a naturally modest pose. In stretching out her legs for the final position in the painting, modesty compelled her to cover her sex with her hand, a gesture which perhaps does more to accentuate it than to hide it.

he was entirely unable to resist giving in to those irreverent impulses that would lead to even greater commotion. Some of these impulses were better hidden than others: Perhaps many viewers were familiar with these lines by Baudelaire—"My darling lay nude / For knowing well my heart / She had kept nothing on but her sonorous jewels"—but how many could possibly have known that the very same bracelet sported by Victorine in the painting once belonged to Manet's very bourgeois mother?

Pantheism and the "New Painting"

A little black ribbon holding a pearl, and some mules, Olympia's only garb, have generated a lot of ink, including from the poet Paul Valéry, who wrote: "Her head is empty; a black velvet string isolates it from the essence of her being" (1932). Michel Leiris used it for the title of one of his later works: *Le Ruban au Cou d'Olympia* (*The Ribbon Around Olympia's Neck*, 1981). The bouquet reminds us that Manet was a dazzling painter of flowers—and would remain so until the end of his life—but it, too, proved shocking: A still-life, a "secondary" genre, was here occupying the same plane as a nude, the nude being a noble genre when painted in an idealized manner "after the ancients," but, in this case, mocked by the body's simplified naturalism. "[Manet's] real vice was a kind of pantheism, esteeming a head no more highly than a slipper, and sometimes assigning more importance to a bunch of flowers than to the face of a woman, as in his famous painting with *The Black Cat*," wrote Thoré, in 1868. This "pantheism" was vindicated by the "new painting," the new view of nature and art that—a few years hence—would be given the

Manet was always passionately interested in making prints, both engravings and lithographs. He was one of the founders of the Society of Etchers, an organization created in May 1862. That year his own engravings were acclaimed in the last piece of art criticism published by Baudelaire, "Painters and Etchers," which predicted the revival of artists' original printmaking.

The Cat and the Flowers (1869, above) repeats a motif in *The Balcony*, which Manet was then in the middle of painting, but the little dog in the painting was replaced by a cat, Manet's favorite animal. This engraving was intended to illustrate a book titled *The Cats* by Champfleury, a strong supporter of Realism, for whom Manet had already created the famous poster depicting two tomcats on a roof, one black and one white.

name that would make its fortune. It is significant that it was Claude Monet himself, the incontestable leader of this movement, who, seven years after Manet's death, would take it upon himself to raise funds to buy the *Olympia* and offer it to the French state in 1890. The painting was exhibited first at the Musée du Luxembourg, and finally, seventeen years later, at the Louvre; there it was hung in the Salle des Etats, next to Ingres' *Grande Odalisque.* Thanks to the *Olympia,* then, Manet triumphed—posthumously, at any rate—well beyond his hopes.

> "Like a man who has fallen in the snow, Manet made an impression on public opinion."
>
> Champfleury

> "If the canvas of the *Olympia* was not slashed and destroyed, it is only because of the precautions that were taken by the administration."
>
> Antonin Proust

"I Painted What I Saw"

Seven years after the *Olympia* scandal, a venomous article by Jules Claretie accusing

THIS WORK BY MANET WAS THE CULMINATION OF THE EXHIBITION. M. COURBET KEPT HIS DISTANCE FROM THE FAMOUS BLACK CAT. THE GREAT COLORIST'S PREFERRED MOMENT WAS WHEN THIS WOMAN WAS ABOUT TO TAKE A BATH, WHICH STRUCK US AS BEING URGENTLY NEEDED.

Manet of once again "firing off a revolver" to draw attention to himself, provoked this response from the painter: "How foolish must one be to have said that!… I render as simply as can be the things I see. Take *Olympia*, could anything be plainer? There are hard parts, I've been told. They were there. I saw them. I painted what I saw."

But by 1865, the catastrophic impact of his painting had nearly crushed him. "I would like to have you here, my dear Baudelaire, the insults rain down on me like hail…. I should have wished to have your sound opinion of my work," Manet wrote to his friend, who was then in Brussels. The answer was a famous letter, severe and galvanizing, that clearly demonstrates the high regard the poet held for his friend: "I must speak to you again about yourself. I must apply myself to showing you what you are worth. What you seem to expect is ridiculous. They make fun of you; their jokes set you on edge; they aren't fair to you, etc., etc. Do you think you are the first man to find himself in such a position? Do you have more genius than Chateaubriand and Wagner, who were also roundly made fun of? Still, they survived. And, not to instill you with too much pride, I will tell you that these men are models, each in his field, in a very varied world, and you, you are but first in the decrepitude of your art. I hope that you won't resent me for the matter-of-fact way I treat you. You know the affection I have for you."

The poet's usage of the word "decrepitude" probably did not do much to raise the spirits of the disheartened painter! But he knew Baudelaire well enough to understand what he meant, that in an era he condemned for its "bourgeois and democratic stupidity," little inclined to elevate and recognize genius, his young friend not only was the "first," but also represented hope for the future.

Olympia's black cat quickly became a symbol for the scandalous Manet. Théophile Gautier, who had defended Manet a few years earlier, found the work empty and dirty—in particular, the "cat that leaves the trace of his muddy feet on the bed."

Allusions to "Michel's mother and her cat," a popular vulgar song, also turned out to be unavoidable. The cat, whose tail resembles a question mark, left the impression that Manet wanted to poke fun at the bourgeoisie. Left: A caricature by Bertall.

The Role of Shadow

The brilliant and charming Manet "nursed neurasthenia, his cocky appearance notwithstanding," recalls the painter Pierre Prins, who knew him fairly well. A sense of drama and images of death are not uncommon in his work; they make their appearance as early the 1860s, a full two decades before death cast its shadow upon him. He would then say to his old friend Antonin Proust that he "always had the desire to…paint Christ on the cross. What a symbol! One could search until the end of time, and one would never find anything comparable. Minerva, that is fine; Venus, that is all right. But the image of heroism, the image of love, could never equal the image of suffering. That is the root of humanity. That is its poetry."

One should not underestimate Manet's religious works. At the same time that he presented the *Olympia* to the Salon, Manet had also sent *Jesus Mocked by the Soldiers*—the pair suggesting a sort of diptych composed of a degraded Venus and a Christ with a laborer's body (represented by the well-known studio model Janvier, who was also a locksmith), a double scandal to complement the publication of Ernest Renan's controversial *La Vie de Jésus* (*The Life of Jesus*, 1863), a positivist portrait of Jesus as "a great man" rather than the Son of God. More than anything else, Manet's painting was about the drama of death and was by no means merely another edifying "historical tableau" of the sort he had produced the previous year.

The subject of another painting on this theme, *The Dead Christ and the Angels,* submitted to the Salon of 1864, was a very naturalistic cadaver, a pretext for a brilliant "piece of painting"—a proletarian body sporting the swarthy hands and feet of a worker placed like a still life on a white drapery and

To reproduce *The Dead Christ and the Angels* as an engraving, Manet made a watercolor sketch in reverse.

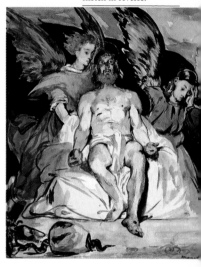

Opposite: *The Dead Christ and the Angels,* 1864.

Courbet made fun of Manet's painting, averring, ostensibly in defense of Realism, that he himself had never seen angels! Much later, Degas, taking issue with Courbet's jest, exclaimed, "I don't give a damn about all that; there is a drawing in this *Christ with Angels*! And what transparency of paint! Ah! The devil!"

vaguely supported by blue-winged angels with pretty feminine faces who appear impervious to the tragedy before them.

Yet another, *The Dead Man* (or *The Dead Toreador*), was cut from a larger work shown at the same Salon of 1864, *Episode from a Bullfight,* which was widely

"I like the angels in the background, these children with their big blue wings who have such a sweet and elegant strangeness."
Emile Zola, 1867

ridiculed. In a way this is fortunate, since it is only from caricatures that appeared alongside the scandalous reviews that the original work was able to be reconstituted. The bull was evidently microscopic,

and the background comprised of the audience at the fight unconvincing, even in Manet's own estimation (his trip to Spain would not come until the following year). In painting his dead toreador, he must have remembered the *Dead Soldier* (at the time wrongly attributed to Velázquez), a work he had seen as a child in the Louvre's Spanish wing.

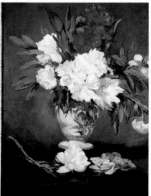

We cannot know today what moved Manet, in 1877, to paint his very realistic-looking *Suicide,* though it could have had to do with a tragic episode that had occurred over a decade earlier: One day he had discovered the body of one of his young models—the one in the *Child with Cherries* (1859)—hanging in his studio. (Baudelaire's *The*

About *Peonies in a Vase on a Stand* (1864), the poet André Fraigneau said, quite aptly, that it is "the story of the death of a flower."

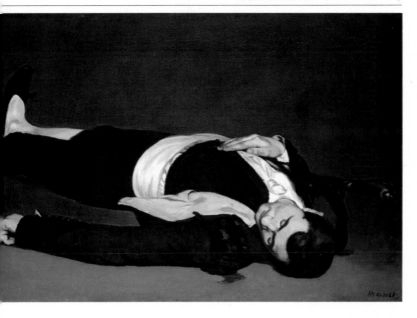

Rope, a tale dedicated to Manet, was also inspired by this tragic incident.)

A kind of morbid fascination was also present in a number of Manet's still lifes, dating—like *The Dead Man* and *The Dead Christ and the Angels*—from 1864 and representing fish, or even flowers. These are meditations on death in the tradition of the *vanitas,* or macabre still-lifes of the 17th century, though in Manet's style: somehow simultaneously lighthearted and pitiless.

In his 1867 show, Manet titled this work *The Dead Man,* thus avoiding all association with folk-loric anecdote. Henri Matisse, upon discovering the painting in the United States in the 1930s, wrote enthusiastically, "I saw it in the midst of a magnificent collection of works from all periods, between Rembrandts and Rubens, and it astonished me by the way it equaled its neighbors."

Opposite above: An 1864 caricature of the original work, before Manet cut it up, retaining only the figure of the dead toreador.

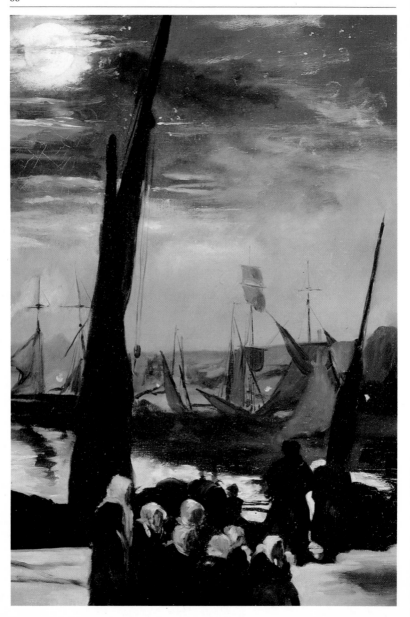

Like Delacroix before him and Picasso later on, Manet was a painter who had—in addition to his own genius—the ability to attract brilliant writers. When Baudelaire, who had been the first to support him, descended into the obscurity of illness and, ultimately, death, the young and thundering Emile Zola appeared to take his place. And when this staunch ally "let him go," Stéphane Mallarmé materialized.

CHAPTER IV

THE PAINTER OF MODERN LIFE

All that one associates with Manet is in this painting, *Moonlight over Boulogne Harbor* (detail opposite and whole painting right), painted during the summer of 1868 or 1869. It is at once realistic—it depicts the return of the fishermen to the pier at night, observed from the window of Manet's hotel —and laden with historical references. Moreover, it is an admirable study in blacks.

When he defended Manet for the first time in the
Paris newspaper *L'Evénement*, just after the
Salon's jury rejected *The Fifer* in 1866, Emile Zola
was twenty-six years old. The following year he
published a dazzling defense of Manet's work
and of naturalism in general, which was at the
same time a polemic on behalf of his own aesthetic
beliefs. In Manet's work he had discerned a talent
"comprised of justice and simplicity." "I do not think
it is possible to obtain a more powerful effect with
less elaborate methods.… The place of M. Manet is
decidedly at the Louvre," he asserted, "just as it is
for Courbet, and for any artist with a strong and
uncompromising temperament."

"He does not retreat
from the brusqueness of
nature.… Since no one
has said that, I will say
it, I will shout it. I am
so certain that Manet
will be one of the masters
of tomorrow that I
believe that I would
make a good deal, had I
the means today to buy
all of his canvases.**"**
Emile Zola, 1867

Manet Seen by Zola

Even if it eventually transpired that Zola misunderstood
Manet's work and modern painting in general—notably

that of his childhood friend Paul Cézanne—and even if
his vociferous defense of Manet, the man who best repre-
sented the avant-garde in 1866 and 1867, was deeply
mixed up with his own professional strategies as a young
writer, one cannot overlook the fact that he was the only
one to put up a good fight on behalf of a painter who
had none too many critics on his side. Armed with
lengthy studio discussions with Manet, Zola knew how to

Next to a photograph
of Emile Zola
(above left) is the title
page spread of the first
edition of the novelist's
1867 pamphlet about
Manet, with a portrait of
the painter engraved by
Félix Bracquemond.

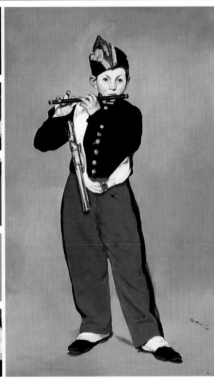

"My favorite work is without a doubt *The Fifer* [1866, left], one of this year's rejects. On a luminous gray background, the young musician stands forth, in uniform, red trousers with fatigue cap. He blows into his instrument, full face and eyes forward. I said before that M. Manet's talent lies in exactness and simplicity, and I was thinking in particular of the impression this canvas had made upon me.... M. Manet is of a dry temperament, subsuming detail. He delineates his figures sharply...; he goes from white to black without hesitation, rendering objects in all their vigor, detached from each other. His entire being compels him to see in patches, in simple elements charged with energy. One could say that he is satisfied with finding related values and then juxtaposing them on a canvas. In this way the canvas is then covered with a strong, solid painting."

Emile Zola,
from his first article on
Manet in *L'Evénement*,
7 May 1866

—and did—defend with ardor the new trends in painting.

Manet's canvases embodied Zola's own definition of a worthy work of art, whether literary or visual—that is, "a corner of nature seen through a temperament." Zola was also the first of a long series of writers to grant Manet a "formalist" vision, meaning that he was an artist for whom the subject was less important than the style and the manner of painting, although Manet, of course, never neglected the essentials. No doubt Zola had in part taken up Manet's own comments: "If you want to reconstitute reality, you have to take a few steps back. Then something strange takes place, each object is put into its proper context, the head of the *Olympia* is separated from the background in striking relief, the bouquet becomes a marvel of brilliance and freshness.

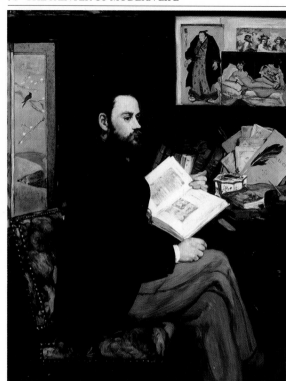

The justice of the eye and the simplicity of touch have produced this miracle; the painter has proceeded as nature would have, by light masses, by large patches of light, so that his work has a bit of the rough and austere appearance of nature itself."

Zola Seen by Manet

The portrait that Manet made of Zola in 1868, which was accepted at that year's Salon, publicly announced the intellectual bond between the two men. Their alliance was indicated in the painting by means of several clues: Among the books Manet painted was the pamphlet that Zola had just finished dedicating to him; the room is, in fact, Manet's studio, carefully rearranged to resemble a writer's study; the Japanese print, one from Manet's

As in *The Collector of Prints* (1866, above), by his friend Degas, Manet portrayed his model in his *Portrait of Emile Zola* (1868, left) surrounded by objects—mainly Japanese, an indication of his modernist sensibility. Above Zola's pen—and the sky-blue pamphlet that he had just finished dedicating to Manet—the photograph of the *Olympia* seems to be thanking the writer for his enthusiastic essay on this "masterpiece which is truly the flesh and blood of the painter,... the complete expression of his temperament; [which] embodies him entirely and which can embody only him." Manet amused himself by changing the position of the head a little in order to direct Victorine's malicious gaze toward the future author of *Nana*.

collection, suggests the passage in Zola's work in which he links "[a] simplified painting…to Japanese engravings, which resemble it in their strange elegance and their magnificent stains"; the small engraving after Velázquez's *Los Borrachos* suggests conversations Manet and Zola may

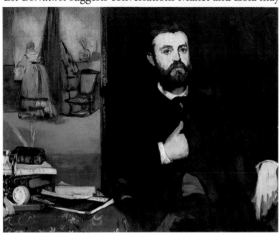

have had in the studio about the Spanish painter; and the book Zola holds distractedly is a volume of Charles Blanc's *L'Histoire des Peintres* (*The History of Painters*, fourteen volumes published between 1861 and 1878), one of Manet's wellsprings of reflection and inspiration.

Zola was not the only friend of whom Manet made a superb series of portraits. He painted Théodore Duret in the manner of Goya, doubtless remembering their visits together to the Prado (it was in a restaurant in Madrid in 1865 that Manet met the future critic and collector who would later dedicate his first serious work to the Impressionist painters); and Manet painted many portraits of his friend Zacharie Astruc—a writer, critic, and sculptor. It is Astruc who nonchalantly plays the guitar in *The Music Lesson*.

The Lady of *The Balcony*

In the late 1860s another face appears in Manet's work, one of a remarkable and unusual intensity—that of Berthe Morisot. This young woman painter, to whom

The person who was known within the artistic community as the "handsome" Zacharie Astruc (left) was one of Manet's oldest friends. At the time of this portrait (1866), he was mostly a poet, writer, and critic and had not yet become a sculptor. It is his rather mediocre poem that inspired the title of the *Olympia.* Astruc had been a defender of Manet in the press since 1863, three years before Zola. And it was he who planned the trip that Manet made to Spain in 1865. A man who, like Manet, was very enamored of Japanese culture—indicated by the small volume on the table—he had probably introduced Manet to the art of Japanese prints. The very sketchily painted left hand was likely an allusion to Titian's *Man with the Glove* at the Louvre. When Fantin-Latour painted Manet among his friends in the *Studio at Batignolles* (1870), he showed him painting another portrait of Zacharie Astruc.

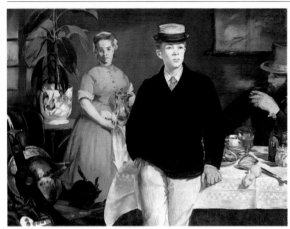

Fantin-Latour had introduced Manet at the Louvre many years earlier, contributed her ardent and melancholy beauty to *The Balcony* (1868–9), an updated rendition of Goya's *Majas on a Balcony* (c. 1811).

The work was accepted at the Salon of 1869, together with *The Luncheon*. Once again, both works baffled the

The three models in *The Luncheon* (1868, left) were as follows: in the foreground, Léon Leenhoff, as an adolescent; behind him was a family servant, and, seated in the rear, a neighbor and former member of Couture's studio, Auguste Rousselin. The composition remains enigmatic; the protagonists seem to ignore each other. Why are they wearing hats? Why did Manet borrow these arms, common props of more conventional painters? The black cat of the *Olympia* may also be found, cleaning itself, unaware of the oddity of the scene.

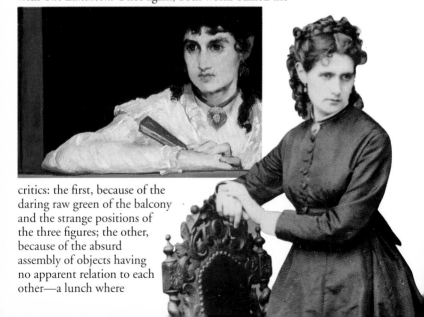

critics: the first, because of the daring raw green of the balcony and the strange positions of the three figures; the other, because of the absurd assembly of objects having no apparent relation to each other—a lunch where

oysters appear to have been served with coffee while a helmet and a pistol rest on a chair. "Why these arms? Had the lunch followed or preceded the duel?" asked the wry Théophile Gautier.

In fact, both of the works were affectionate portraits of Manet's closest friends and relations, situated in settings that were suited to their personalities. In *The Luncheon* Léon Leenhoff is posed in the family's summer apartment. As for the models of *The Balcony*—Berthe, the young musician Fanny Claus (taking off her gloves), and the painter Antoine Guillemet—these were three young artist friends of Manet, posing in a sort of Spanish parody, a comedy of elegant contemporary life.

Berthe Morisot—who in 1874 would become Manet's sister-in-law when she married his brother Eugène—was a very fine painter, a

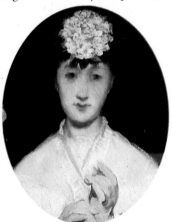

student of Camille Corot's who was later strongly influenced by Manet and Renoir and would become one of the most active and faithful members of the Impressionist group. Her charm and her intelligence, her talent as a painter, and her kind of wild beauty endeared her to Manet, and for many years she would remain one of his favorite portrait models. The fascination was mutual.

Berthe Morisot, photographed in 1873 (opposite below right), the main model of *The Balcony* (1868–9, overleaf), described in a letter to her sister her impressions of the Salon of 1869, where the work was shown along with *The Luncheon*: "As always, [Manet's] paintings give the impression of a fruit that is wild, or a bit unripe. They are far from displeasing to me…; I am more strange than ugly; it seems that the curious have been spreading the word that I am a femme fatale." Landscape painter Antoine Guillemet and the violinist Fanny Claus, who played music with pianist Suzanne Manet, were the other models for *The Balcony*.

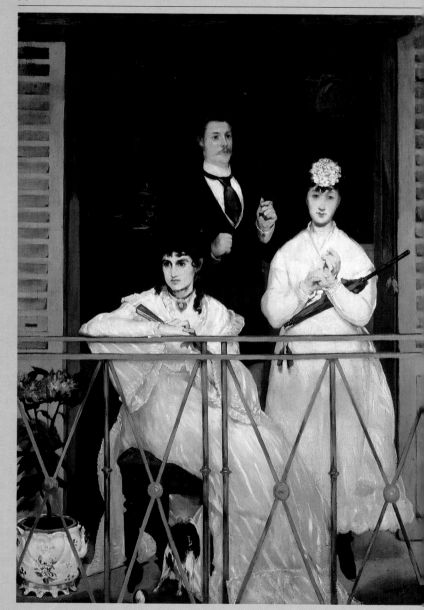

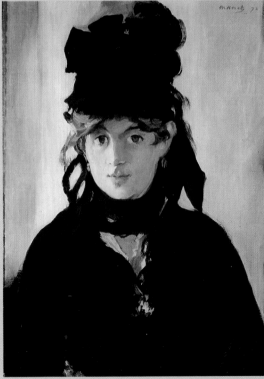

The protagonists of *The Balcony*, three of Manet's friends, appear to be playing different stock characters: the woman on the right is a sweet comic ninny; the self-satisfied dandy is in the center; and Berthe Morisot, all mystery and drama, foreshadows the heroines of Henrik Ibsen and Anton Chekhov. Manet painted *The Bunch of Violets* (1872) posed on a fan in 1872, and then offered it to his model. Below: *Berthe Morisot with a Bunch of Violets* (1872).

"There's nothing greater in Manet's work than a certain portrait of Berthe Morisot, done in 1872.... Above all, it is the *Black*, the absolute black, the black of a mourning hat and the little hat's ribbons mingling with the chestnut locks...that affected me. The full power of these blacks, the cold simplicity of the background, the clear pink-and-white skin...; the tangle of locks, ties, ribbon, encroaching against her face; this face with its big eyes, vaguely gazing in profound abstraction, and offering, as it were, *a presence of absence*."
Paul Valéry
"Triomphe de Manet"
(exhibition catalogue)
1932

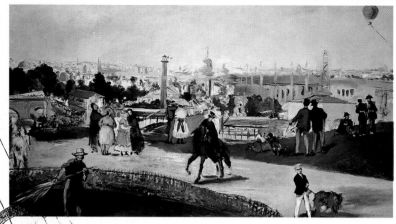

Contemporary Scenes

In the 1860s, Manet revealed the broad range of his talent by painting scenes of contemporary life, though in a slightly contrived way, as in *Music in the Tuileries,* where he had "made up" in the studio a series of figures under trees. Around 1867—no doubt inspired by Degas, his friend and rival in modernism—Manet painted the astonishing *Races at Longchamp,* a view that was neither an ordinary side view nor a scene from before the start, but a radically frontal one, with the horses heading straight for the spectator.

During the course of two summer holidays spent in Boulogne, Manet painted several maritime scenes—mainly ones of ports—including *Departure of the Folkestone Boat* (1869), a luminous, pre-Impressionist composition, and *Moonlight over Boulogne Harbor,* inspired by 17th-century Dutch paintings, which shows a group of women awaiting the return of the fishing boats in the evening. Manet loved to describe the various activities associated with the sea, whether they were of work—*Return of the Catch, The Pier at Boulogne, Caulking the Boat, Workers of the Sea*—or leisure—*The*

Nadar, in his balloon, "elevating photography to the level of art," was caricatured by Honoré Daumier (left). The same balloon appears in Manet's 1867 panorama of the Universal Exposition (above).

Beach at Boulogne or *On the Beach,* the latter showing his wife, Suzanne, and his brother Eugène all wrapped up against the wind.

It would be tempting to think that the funeral depicted in Manet's unfinished canvas *The Burial* (1867–70) is Baudelaire's (he was buried in September 1867), but we cannot be certain. The style is quite similar to that of a large urban landscape that Manet made that same year, showing the buildings of the Universal Exposition. The scene was done on the spot and features strollers, members of the militia, dandies, and a gardener, as well as a few familiar faces: One can discern the young Léon walking his dog in the foreground, and, at the top on the right, the balloon from which Manet's old friend and accomplice Nadar was photographing Paris and the fair.

Like Degas, Manet painted horse races during the 1860s. It was primarily the animation of the scene that intrigued him, probably more so than the horses themselves. Paintings or lithographs (below is the 1865–72 print of *The Races*), his works on the subject used an explosive technique.

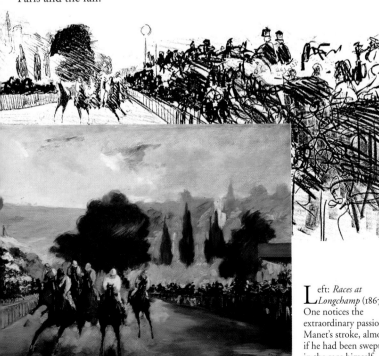

Left: *Races at Longchamp* (1867?). One notices the extraordinary passion of Manet's stroke, almost as if he had been swept up in the race himself.

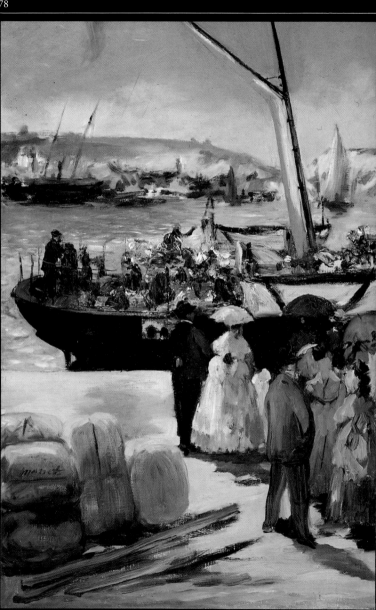

Manet spent the summer of 1873 at Berk-sur-Mer, painting seascapes outdoors. Oddly enough, these are less cheerful and Impressionistic than those he painted years earlier. In 1873 he seemed to be more interested in maritime laborers than in scenes of village or harbor life. Though a quintessential urban Parisian, Manet had a legitimately acquired knowledge of, and undying passion for, sea life. In *Caulking the Boat* (1873), Manet shows fishermen tarring their vessel. The painter here returns to his beautiful effects of black, centering the painting around the brilliant orange flame against the black-tarred hull—recalling the pink cape/black garb contrast in *The Dead Man.*

AUX AMIS
DE LA
VIEILLE GAÎTÉ FRANÇAISE

MUSÉE DROLATIQUE

Below: *Portrait of Edouard Manet* by Henri Fantin-Latour, 1867.

THE TEMPLE OF TASTE
TIRED OF SEEING HIS WORKS REJECTED FROM OFFICIAL EXHIBITIONS AS A RESULT OF SYSTEMATIC OPPOSITION, M. MANET HAS TAKEN IT UPON HIMSELF TO ASK THE PUBLIC TO MAKE THE DECISIONS OF A JURY; WHOEVER THEY MIGHT BE, HE WANTS JUDGES, AND HE WILL FIND THEM.

The Pavilion Near the Alma Bridge

The first of April was the opening of the Universal Exposition, in which were displayed not only the latest technological advances but also works of art. Naturally the organizers selected canvases by recognized contemporary Académie painters—Jean-Léon Gérôme, Jean-Louis-Ernest Meissonier, and Alexandre Cabanel—but Realists such as Camille Corot and Jean-François Millet were given exhibition space as well. Manet, however, was not chosen. Thus, he decided to organize —at great expense—his own private exhibition of fifty works, to be held in a pavilion he had built near the Exposition grounds at the Pont d'Alma. A letter to Manet from his mother during this time shows her very worried to see her son so "wasting" his inheritance.

His most beautiful works from the previous ten years were all there—an

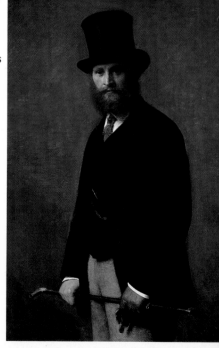

DOUARD MANET, – par G. RANDON.

astonishing assemblage and the most complete one to date. There would never again be a retrospective of Manet's work that was quite so comprehensive. Unfortunately, there are no photographs of the installation. But there is an accurate log of sorts: All the works were caricatured in a pamphlet by Randon.

Despite a well-thought-out strategy—"I am going to risk the lot, and, with the help of men like you, I plan to succeed," he wrote to Zola—and despite the advertising in the Exposition catalogue, as well as the publication of six hundred copies of Zola's pamphlet on Manet, the exhibition met with neither critical nor popular success. Still, some people were very impressed, like the critic Champfleury: "I was struck most of all by the way works conceived in various periods held up. From the first canvas to the last, there was total cohesiveness."

LOLA DE VALENCE

THE PHILOSOPHER

Manet Speaks

Manet himself wrote the preface to the exhibition catalogue, although he coyly discusses the painter in the third person. In it he defends himself as having been a victim of the jury and announces that he can no longer wait for an official endorsement: "Since 1861, M. Manet has been exhibiting or trying to exhibit. This year he has decided to show the sum total of his works to the public....

THE ARTIST

A few of Randon's cartoons of Manet's Alma Pavilion exhibition. They appeared in *Le Journal Amusant* (*Entertaining Journal*) in June 1867.

The artist does not say, 'Come and see faultless work,' but rather, 'Come and see sincere work.'" In this preface one finds for the first time the word "impression" linked in a positive way to the new painting methods: "It is sincerity that gives these works a character that makes them resemble a protest [today we would say a provocation], albeit that the painter's only aim was to render an impression." The term would soon be in vogue, but at first critics used it only derisively.

Although Manet's private exhibition was ignored by

THE REGISTER

the general public, it proved to have considerable and lasting impact on the pictorial avant-garde and would influence most young painters of the next generation, who were finally able to see Manet's oeuvre in its entirety—the majority of which had, of course, either been criticized or rejected for the past six years.

Manet was included at the Salon held that same year, but not in the expected way: Fantin-Latour had submitted a very beautiful portrait of his colleague, which was dedicated, "To my friend Manet." Every

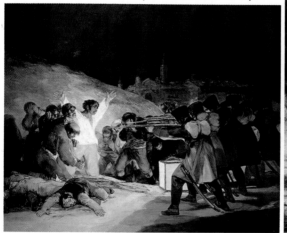

Salon visitor could thus see the elegant and serious image of the painter who was so regularly the center of scandal. "Ah, yes!" wrote an anonymous critic, "this very correct young man who is well groomed, well dressed, whom one would mistake for a hero of the racetrack, is the painter of the black cat who was famous for being laughed at, and who was depicted as a hairy dauber, sporting thinning red hair and smoking death's-head pipes…. Now, if he had [earlier] been shown to have been so well turned out, the public might have been capable of granting him a lot of talent."

Manet, Painter of History

In the midst of the euphoria over the Universal Exposition, news spread of the execution of Archduke

"It's sheer Goya, and yet Manet was never more himself," Renoir observed to the art dealer Ambroise Vollard in a discussion of *The Execution of Maximilian.* It is true that Manet's composition, even in its first rough version shown here (1867, above), was taken directly from Goya's *The Third of May, 1808* (above left), which he had seen in Madrid two years earlier.

In 1864 Louis-Napoleon had installed Maximilian, archduke of Austria, as emperor of Mexico without giving him adequate military support to resist the nationalist troops. Manet was in Boulogne on 1 July 1867 when a piece of shocking news began to spread through Paris: "The Emperor Maximilian was shot under [Mexico's self-proclaimed president Benito Pablo] Juárez's orders. What a tragic dénouement to the ruinous and bloody madness of the war in Mexico!" noted dramatist Ludovic Halévy. Manet's work was obviously and justifiably felt to be the manifestation of his anti-imperialist opinions.

Maximilian of Austria, whom Louis-Napoleon had helped install as emperor of French-controlled Mexico without sufficient military support for protection. Overcome with indignation and perhaps identifying with the victim—he who was fired upon symbolically every year by the Salon's jury and by the press— Manet, whose entire work had hitherto distinguished itself by its lack of historical referents, now decided to paint *The Execution of Maximilian*. For a year and a half Manet worked on several versions of the large canvas as well as on lithographs intended to popularize the work, since he would not even attempt to submit it to the Salon. The overall composition is

similar to that of Goya's *The Third of May, 1808,* though simplified and de-dramatized. While Goya had depicted an event just before the execution—the soldiers taking aim—Manet chose to represent the most tragic moment—when the shots were actually fired.

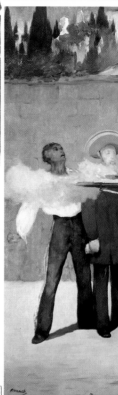

There is nothing melodramatic about Manet's canvas. The scene appears to be frozen, the trio of victims dignified, and the soldier on the right, calmly reloading his gun, is the quintessential portrayal of indifference. In the final version, Manet dressed the firing squad in the uniforms of French soldiers, with the intention of stating as clearly as possible who he felt was responsible for the tragedy.

It may seem surprising that Manet—a confirmed republican who lived through the months-long siege of Paris by German troops in 1870 and who, while not actually a participant, was in the capital a few days after that same summer's bloody populist revolt against the newly installed government—would not have based another major work on the year's horrific events. But this time he limited himself to making a

Barricade du F.^g S.^t Antoine angle de la rue Charonne. 18 Mars 1871.

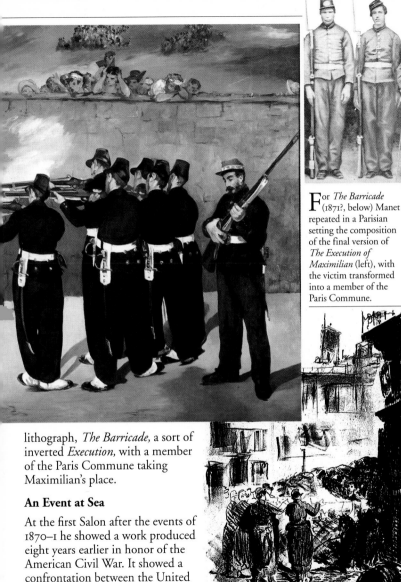

For *The Barricade* (1871?, below) Manet repeated in a Parisian setting the composition of the final version of *The Execution of Maximilian* (left), with the victim transformed into a member of the Paris Commune.

lithograph, *The Barricade,* a sort of inverted *Execution,* with a member of the Paris Commune taking Maximilian's place.

An Event at Sea

At the first Salon after the events of 1870–1 he showed a work produced eight years earlier in honor of the American Civil War. It showed a confrontation between the United States Navy's *Kearsarge* and the Confederates' *Alabama*. Here, in

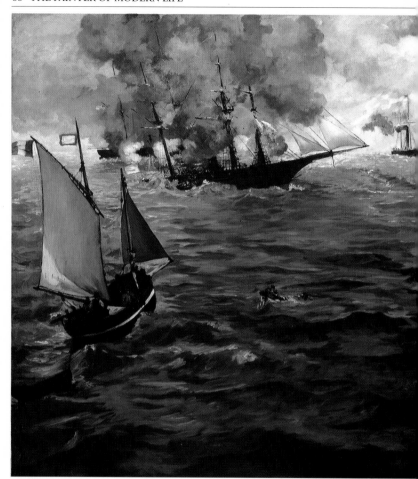

what was above all else a superb seascape, the viewer participates in another sort of execution, that of a ship in the process of sinking after having been hit by another vessel, just barely visible behind the first.

The following summer, in Boulogne, Manet again painted the *Kearsarge* in a series of seascapes, the only scenery he liked to paint—possibly because it reminded him of his early stint as a seaman.

"M. Manet has thrown back his two vessels to the horizon. He had the knack of foreshortening them...but the sea that he swelled all around...is more terrifying than the combat."

Barbey d'Aurevilly

COMBAT NAVAL
Par M. MANET.

Manet made two more maritime paintings at the beginning of the 1880s. Both show an incident that had occurred six years earlier, when polemical journalist Henry Rochefort had fled from New Caledonia—where he had been in a French jail—to Australia in a whaleboat. The image of the escaped convict at sea evidently started to appeal to Manet when reports of Rochefort's amnesty and return to France began to circulate in the newspapers. "I saw Manet; he was very taken [with the idea of creating] a sensational work for the Salon: the escape of Rochefort in a rowboat in the open sea," wrote Monet to Théodore Duret in early December 1880. (The turbulent "open sea" in fact was re-created from memory in his studio.)

In the end, Manet submitted neither work to the Salon (in the first, the occupants of the rowboat are quite close to the viewer and recognizable; in the second, the boat is further away, the occupants barely discernible). Instead, he submitted a portrait of the pardoned radical socialist which, despite the misgivings of several members of the Jury, was accepted in the Salon of 1881.

Even when it came to a seascape, the caricaturists could not forget Manet's black cat! *Battle of the Kearsarge and the Alabama* (1864) is opposite, and the work as seen by Bertall is at left.

In 1880, a government amnesty permitted the anti-imperialist polemicist Henri Rochefort to return to France. Manet then commemorated the journalist's escape from prison in New Caledonia six years earlier (below), faithfully following the narrative that Rochefort recounted to him.

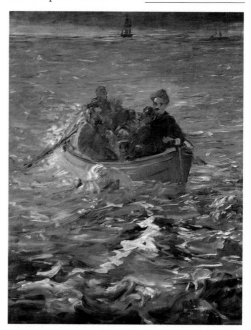

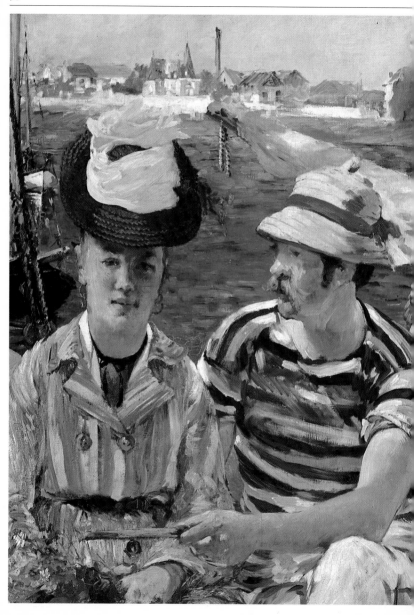

"You understand, Manet is as important for us as Cimabue and Giotto were for the Italians of the Quattrocento. Because it is the Renaissance that is coming!"

Auguste Renoir to his son, Jean

CHAPTER V

THE GODFATHER OF IMPRESSIONISM

Argenteuil (1874, detail opposite), a painting shown at the first official Salon held after the Impressionists' debut exhibition, appeared to support their method of painting. This wash drawing of painter Eva Gonzalès's younger sister on the beach (1879–81, right) accompanied Mallarmé's translation of Edgar Allan Poe's poem *Annabel Lee.*

Manet opened up new directions in painting to many of the young painters in France in the 1860s—including Bazille, Cézanne, Monet, and Renoir. Collectively these dissenters from the conservative guidelines of the Académie were referred to as Realists, Intransigents, Naturalists, or, simply, "Manet's gang." When they showed as a group in 1874, they called themselves Independents, but the name that has stuck with them over the decades is Impressionists.

The Batignolles Studio

At one time they were also known as the "Batignolles group," a reference to the part of Paris where Manet had his studio and where there was an abundance of cafés: le Guerbois, la Nouvelle-Athènes, le Café de Bade. In showing *Studio at Batignolles* at the Salon of 1870, Fantin-Latour officially acknowledged Manet —portrayed busily at work in the center of the canvas—as the group's leader. Bazille painted the same protagonists in his own studio, also granting Manet a central role, in front of his easel.

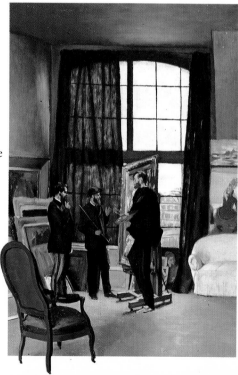

John Rewald, the foremost historian of Impressionism, has remarked that "Corot attracted the timid minds of the new generation, while the more daring ones turned toward Courbet and Manet." Even so, Manet could not be said to have headed a school. As

This is Manet's very lifelike rendering of a common Parisian café scene of the 1860s and 1870s (1869, left). Perhaps it is one of those in the Batignolles where Manet often went at the end of the day?

This caricature by Cham (1868, opposite) shows to what extent a young painter who refused to conform to the tastes of the Salon jury would be immediately associated with the scandal maker Manet. The title is *Painting Jury*, and the painters are asked: "Do you admit that you committed this work? Do you have accomplices? Are you part of M. Manet's gang?"

Armand Silvestre recalls, he did not have the temperament for it: "I never knew anyone whose personality was more devoid of solemnity." Nonetheless, he attracted these "young Turks," as much by his charm and convivial spirit as by his talent and scandalous reputation. Though always exceedingly generous to his young friends—in his later years, he would financially support the more impoverished ones, especially Monet—he was still surprised and perhaps sorry to see himself allied with, even standing out among, those whose work was being censured by the Académie. (An extreme example of this is that at the Salon of 1865, in the middle of the scandal over the *Olympia,* Manet, to his annoyance, found himself being both congratulated and criticized for his seascapes! In fact, they were Monet's.)

Manet welcomed young artists who came to see him paint or listen to him speak. At left, one of them, Léon Lhermitte, has drawn him at his easel. On the facing page is a detail of Bazille's painting *The Studio on the Rue Condamine,* which commemorated a visit from Manet. From left to right we see either Astruc or Monet, Manet in front of a painting, and the tall Bazille himself, observing and listening to him.

Manet and Monet

In fact, the men quickly became good friends. Cézanne had a grudging admiration for Manet and loved to shock the dandy with his exaggeratedly bohemian manners, and Manet is known to have responded with affection to the admiration of Renoir and Bazille, but it is clear that it was with Monet that he shared the most. Manet portrays him in works filled with fond allusions to the specific talents of the future master of

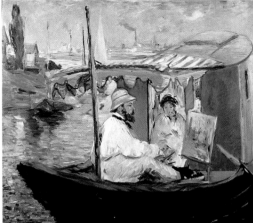

Impressionism. Monet is shown painting on his boat in the middle of the water—water being a major element in Monet's work both at the time and well into the future; he was also portrayed with his family in his garden at Argenteuil. For this occasion, Manet set up his easel outdoors—the first time he had ever done so—as if to pay homage to his younger colleague.

Manet competed against the man he called the "Raphael of the water" on his own turf when he painted *The Grand Canal in Venice* (1875) as he did with *Argenteuil* (1874), a brilliant demonstration of the curious new technique called Impressionism. This canvas, partially completed out of doors, was shown at the Salon of 1875, the one

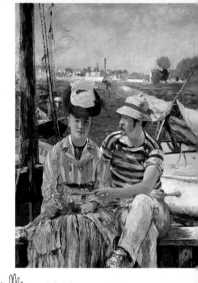

—It's Manet and Manette.
—But what are they doing?
—They are boating, from what I see.
—But this blue wall?
—That's the Seine.
—Are you sure?
—Lady, that's what they told me!

just following the first independent exhibition held by his friends. *Argenteuil* emerged there as a sort of manifesto in their favor; its naturalism was in keeping with their style. But it could also be seen as a challenge to this new form of modernity: The outdoor scene is primarily a double portrait of a pair of working-class boaters, their presence more of a naturalistic illustration than an Impressionist vision of the banks of the Seine.

Paris/Manet; Paris/Monet

The main difference between Manet and Monet became flagrantly apparent in two works they painted on the same day —30 June 1878, to be exact—when hundreds of flags were unfurled in the streets of Paris in honor of the Universal Exposition. Monet's *Rue Montorgueil* —a lyrical ode to the flamboyant colors

These three works by Manet—all executed in 1874—attest to his friendship with Monet during the golden age of Impressionism: *Monet Painting in His Floating Studio* (opposite above); *Argenteuil* (opposite below), framed by the dialogue and figures from a cartoon that appeared in an 1875 issue of *Le Journal Amusant*; and *Boating* (above), which portrays Manet's brother-in-law Rodolphe Leenhoff. This painting was felt to be disturbing because of the intense blue of the water and the lack of a horizon line (a feature reminiscent of Japanese prints).

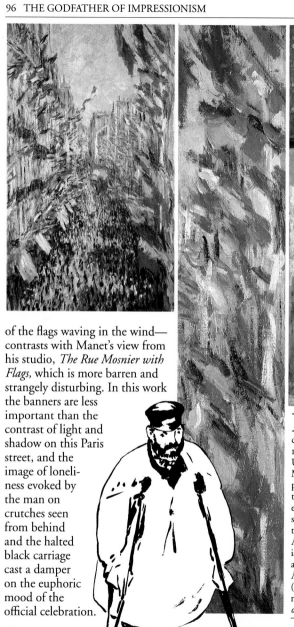

of the flags waving in the wind—contrasts with Manet's view from his studio, *The Rue Mosnier with Flags,* which is more barren and strangely disturbing. In this work the banners are less important than the contrast of light and shadow on this Paris street, and the image of loneliness evoked by the man on crutches seen from behind and the halted black carriage cast a damper on the euphoric mood of the official celebration.

Paris was festooned with brilliantly colored flags on 30 June 1878, in honor of the Universal Exposition. Monet and Manet each produced a work on this theme, and, taken together, the canvases illustrate striking differences in their vision. Monet's *Rue Montorgueil* (above left) is as joyous, buzzing, and airy as Manet's *The Rue Mosnier with Flags* (above) is deserted and melancholy. Left: *Man on Crutches,* 1878.

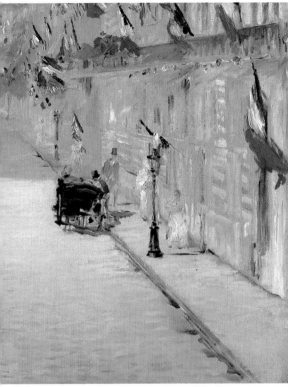

The next year, fascinated as always by urban projects, Manet was hoping to receive a commission to decorate the newly rebuilt Hôtel de Ville. He was interested in painting "a series of compositions representing, to use an expression now hackneyed but suited to my meaning, 'the belly of Paris,' with the several bodies politic moving in their elements; that is, the public and commercial life of our day. I would have Paris Markets, Paris Railroads, Paris Bridges, Paris Underground, Paris Racetracks, and Paris Gardens." This ambitious project was never realized, alas—there was no response to his proposal (and perhaps, to be realistic, it would never have been feasible, since Manet's illness had already set in). Despite all his support for the new art concepts so brilliantly represented by the young Monet, it is evident

2ᵉ année.—Nᵒ 29.　　　　**10 Centimes**　　　　Jeudi 16 juin

ALFRED LE FETIT　　　　LES　　　　FÉLICIEN CHAMPSAUR

CONTEMPORAINS
JOURNAL HEBDOMADAIRE

Administrateur : M. Duffieux, 15, Faubourg Montmartre, Paris. — Un an : **6 fr.**

EDOUARD MANET

that places failed to interest him unless people were stirring in them, and that, similarly, the effects of light—in and of themselves—were not what intrigued him. He mastered them sheerly for the purpose of making his models come alive.

A Decisive Role

"When I used to go see Manet on Sundays [at his studio on the Rue Saint-Pétersbourg]," recalls Proust, "[Manet] did nothing but praise all the devotees of the Batignolles school. He would set out all their works in the best possible light, worrying about finding them buyers, and forgetting about his own works…. He was taken with Claude Monet more than anyone else."

Supportive as he was of them, Manet never participated in the Impressionists' exhibitions, except peripherally in 1876, when he loaned them Renoir's portrait of Bazille. This was not for lack of invitations. The members of the Batignolles group (less Bazille, who was killed in 1870 during the war) and Berthe Morisot all would have been glad of his presence. But Manet had excused himself from their first exhibition in 1874 and every time thereafter—paradoxically preferring to remain faithful to the Salon where he was so regularly rejected.

The quasi-official success he had in 1873 with *The Good Bock* made him even more determined than ever. This portrait—a rather banal composition painted in a Halsian manner in somber tones—did indeed give the impression that

On the first page of *Les Contemporains,* this caricature shows Manet as king of the Impressionists, carried on his palette and seated on a beer barrel, an allusion to his work *The Good Bock* (1873, opposite).

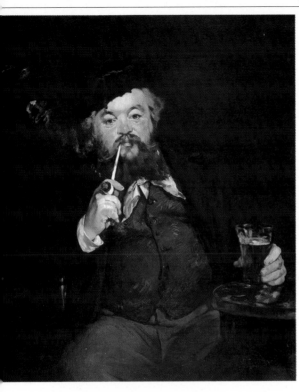

"He is an epicurean of the tavern—fat, red, and jovial—and he believes in nothing so much as his pipe and his beer," said one critic discussing *The Good Bock,* a work that, for the first time in Manet's life, earned him unqualified public acclaim. Here was a "type," a "character," whose traditional image was reassuring. It was, in fact, a portrait of the engraver-lithographer Emille Bellot, a habitué of one of Manet's haunts, the Café Guerbois. Manet had just returned from Holland, and the work attests to the Frenchman's admiration for Frans Hals. As the Paris-based Belgian painter Alfred Stevens put it, "[Manet] drank the beer of Haarlem."

Manet had finally fallen into line. "This year Manet has watered down his beer," they said. Perhaps he believed he had at long last been accepted and would henceforth be able to introduce modernity to the official Salon, rendering needless his participation in such other "secessionist" exhibitions as that of the Impressionists.

"The Realist movement no longer needs to struggle with others. It is, it exists, it must show itself as independent. There must be a Realist Salon. Manet doesn't understand that. I think he is decidedly more conceited than intelligent." Ironically, the person who held these strong views was one of Manet's closest friends: Degas. The relationship between the two men, who were of the same generation and social background, was close but often tumultuous.

Manet and Degas

Compared with the introverted, intellectual, misanthropic, uneasy Degas, Manet was confident and easy—as susceptible to praise and success as to failure, but always sure of his genius and brilliance. He was a celebrity of the streets, "as well known as [the notorious 19th-century Italian patriot Giuseppe] Garibaldi," noted Degas. He was also willful: There is a popular anecdote about the gift Degas presented to Manet, a portrait of his friend listening to Suzanne at the piano; Manet promptly ripped off the entire right side because he did not care for the rendering of his wife's face. "How shocked I was when I saw my study at the Manets," Degas later recalled. "I left without saying goodbye, taking my painting with me. Once home, I took down a small still life [Manet] had given me. 'Monsieur,' I wrote him, 'I send you back your plums!'" But when asked whether the two painters ever saw each other again, Degas exclaimed, "How can one remain on bad terms with Manet!"

Most of the time during those years, according to Berthe Morisot, the two men were inseparable. They were always arguing about who had been first in the modern movement, Degas reproaching Manet for having painted horse-racing scenes or "women in the tub" and Manet retorting that Degas "smelled of the Ecole [des Beaux-Arts]" and that he "was painting Sémiramis when [Manet] was painting modern Paris."

Even if he did not often say it directly to Manet, Degas had great admiration for his friend's prodigious qualities as a painter. He bought a number of Manet's works after his death (Degas

outlived Manet by more than thirty years), including a version of *The Execution of Maximilian,* which had also been cut up—this time by Manet's family—and which Degas personally restored, a poignant gesture in response to the other mutilated work.

"The face of Degas—Socrates, Homer—this mask with the sad gaze, so reflective, compare it with that of Manet, who, at fifty and ill, kept the smile of a successful politician with his charming courtesy."
Jacques-Emile Blanche

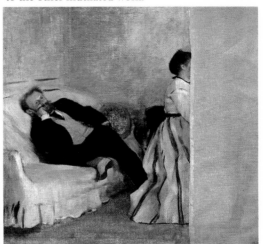

Parisian Landscapes

Manet and Degas had one trait in common that separated them from the group of Impressionists working at Argentueil—Renoir, Sisley, and Monet—and from those at Auvers-sur-Oise—Pissarro and Cézanne: their indifference to landscape. Like his friend, Manet was to the end a painter of people, even if he occasionally painted them outside, as he did in the

Degas (in the photograph opposite) made this wash drawing of Manet leaning against a wall (1866–8, left), as well as this painting (c. 1868–9, above) showing him listening to his wife at the piano. After Manet, unhappy with Degas' depiction of his wife, tore off a section of the work, Degas attached a new strip of canvas to it, no doubt planning to repaint it someday.

1870s. Also like Degas, Manet was first and foremost a man of the city.

Manet's painting *The Railroad* (one must imagine the train having entered the station behind the models) is chiefly a portrait, the last that Manet would do of Victorine, looking altogether believable as a mother, enhanced by a dozing puppy on her knees; her bold gaze is attentive and participatory, but she appears indifferent to the white plumes of smoke just visible behind the iron bars that separate her from her industrial surroundings at the entrance of the Saint-Lazare train station, whose wonderful modernity would soon inspire Monet's celebrated series of paintings.

In *The Laundry* (1875), Manet posed a young woman washing her clothes in a tub in a small garden in the Batignolles quarter. The jury of the Salon of 1876 was particularly set against this work because of its impudent application of two of the most frowned-upon practices of the day: the use of Impressionist techniques of rendering and the depiction of a naturalistic subject. In the eyes of the jury, the work was overweeningly offensive.

"Be Truthful, Let Them Say What They Will"

Faced with the rejection of both *The Laundry* and *The Artist*—a portrait of a colorful habitué of the Café Guerbois, the painter and engraver Marcellin Desboutin —Manet decided to again invite the public to an unusual exhibition in his own studio at No. 4 Rue de Saint-Pétersbourg. The invitation carried the following message in gold letters: "Be truthful, let them say what they will." The crowds thronged—there were some four hundred visitors a day!— and the press made much of the event.

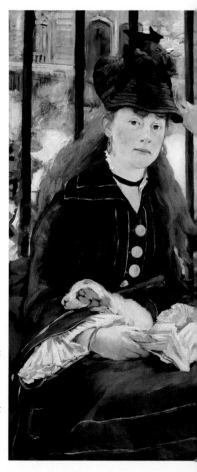

Several articles gave accounts of the exhibition and described the studio and the artist: "What! This man with fine features, placid gaze, blond and well-groomed beard, this man dressed in black, well-scrubbed, well-suited, well-fitted out, is the creator of the Boaters [*Argenteuil*]!";

After having requested authorization from the French Western

Monsieur,

Vous avez bien voulu me demander d'être autorisé à faire dans un de nos dépôts, une étude d'après une machine locomotive montée par son mécanicien et son

chauffeur.

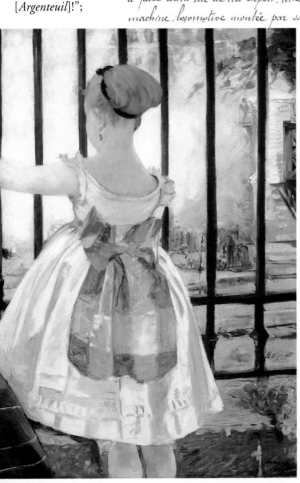

Railroad Company to do a painting in one of its stations, Manet received a favorable response (some of which is printed here). But in 1881 he was already too sick and was unable to realize his idea of painting an engineer atop a locomotive.

Did the caricaturists recognize the smoldering Olympia, maternal and dressed, ten years later? *The Railroad* (1872–3, left) was the last portrait Manet made of his notorious muse Victorine Meurent.

"Seeing themselves painted this way, the unhappy ones wanted to flee! But M. Manet, in anticipation of this, has put up a barrier that prevents their escape."
Cham

or, "M. Manet belongs to that race of decorous revolutionaries, well-brought-up men of the world, like [instigator of the Reign of Terror] Robespierre or [socialist journalist] M. Louis Blanc"; or "He…is paradox incarnate."

Manet and Mallarmé

It is again a poet, Stéphane Mallarmé, who, in an article written in 1876 entitled "The Impressionists and Edouard Manet"—originally published in London in English (but known to have been read by Manet)—conferred the most resounding praise upon the painter, referring to him as the premier painter of light. According to Mallarmé, *The Laundry* was "a work that was perhaps a turning point in an artistic career and was for certain in the history of art…. Everywhere, the atmosphere, luminous and transparent, is one with the figures, the clothes, the foliage, seeming to appropriate a little of their substance and of their solidity, while the contours, eaten by the hidden sun and consumed by the space around them, tremble, melt, and evaporate in the ambient air, which seems to hide their reality in order to preserve the authenticity of the figures. The air rules in absolute reality, as if possessing an enchanted existence, which was bestowed upon it through the sorcery of art."

That same year, Manet made a portrait of Mallarmé about which Georges Bataille justly wrote that it "radiated the friendship of two great minds." It certainly suggests the affectionate attentions of Manet, who must have caught his young friend in a moment of intellectual reverie during the course of their daily conversations in his studio. "I saw my dear Manet every day for ten years, and I find his absence today incredible," the poet wrote in 1885, two years after Manet's death. Mallarmé has described Manet as "freed from the worries of creation, [chattering] in the studio by the light of the lamps; this brilliant talker reveals what he meant by painting, the tidings of destiny

The painter and the poet Mallarmé, the latter Manet's junior by ten years, were very close. After leaving the Lycée Fontane (Condorcet), where he taught English, Mallarmé would spend a long time every evening in Manet's studio. Here is the portrait made of him in the fall of 1876. "Sensitive to the artist's genius, he was no less so to the man's charm," recalled Henri de Régnier. "I heard him speak of Manet only with profound admiration and tender camaraderie." Below is Manet's drawing illustrating his friend's *L'Après-midi d'un Faune* (*Afternoon of a Faun*, 1876).

that were reserved for him, and why and how he painted by irrepressible instinct."

Mallarmé was a close observer of Manet's complex temperament, the extreme contrast between the apparent lightheartedness of the boulevardier and the almost hopeless attraction he felt for a mode of painting so ill suited for the success he so fervently desired. It is Mallarmé who provided us with this famous portrait of Manet, which is at the same time so elliptical and so precise, each word carefully judged: "Among the ruins, goat-footed, a virile innocence in a beige overcoat, beard and thin blond hair, graying with wit. At Tortoni's, an elegant scoffer; in the studio, a fury would seize him before the blank canvas—bewildered as though he had never before painted in his life."

❝The natural light of day, which penetrates and modifies everything, remaining invisible all the while, reigns over this exemplary work [*The Laundry*, 1875, opposite]….❞
Stéphane Mallarmé

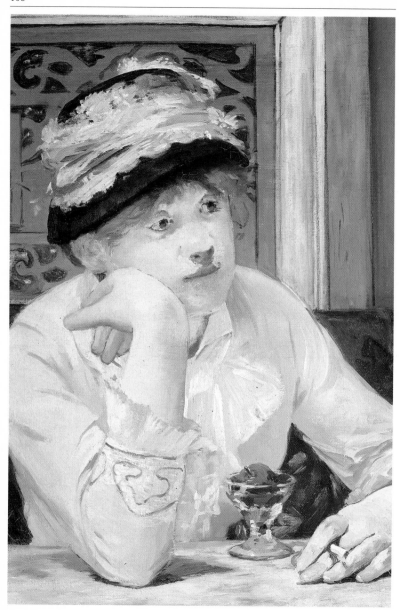

Manet, the man as much as the painter, incarnated glittering Paris at the end of the 19th century—its elegant boulevards, its wit, and its civility, as well as its rebellious spirit and openness to the new, the instinctive rather than the theoretical. In conversation as in painting, he was lively and quick—not frivolous, but the opposite of ponderous. And deft: He headed straight toward his goal with just the right word or brush stroke.

CHAPTER VI
SCENES OF PARISIAN LIFE

Manet evidently gave in to a prank by the photographer Dallemagne, who framed him like a work of art (right). Opposite is a detail of *The Plum* (1878), a café scene for which an actress friend of Manet's posed in his studio.

"Concision in art is a necessity as well as an elegance," Manet advised the young painter Jeanniot, adding these words, which reveal how distant he remained from orthodox Impressionism: "Cultivate your memories; nature will never give you anything but hints—it's like a railing that keeps you from falling into banality. You must constantly remain the master and do as you please. No tasks! No, no tasks!..."

Manet the Portraitist

Manet also gave the following advice to Jeanniot about portraiture: "In a figure look for the highest light and the deepest shadow, the rest will come naturally." These principles had already been observed in portraits of Victorine and Berthe Morisot, whose faces frequently look as if they had been lit by spotlights. This approach is typical of all the works he made from 1870 on, until shortly before his death.

This well-behaved child, posing for his father's friend, is the future playwright Henri Bernstein.

Manet regretted never receiving any formal commissions. He fretted and fumed against the aesthetic choices of his republican friends who finally came into power after 1872, and from whom he had hoped for more artistic tolerance. While it is true that the banker Marcel Bernstein asked Manet to paint his little boy in a sailor suit (Henri, the future dramatist), it was out of friendship rather than because of the painter's prestige. Manet did paint the portrait of the now very official Antonin Proust—France's Minister of Culture under Prime Minister Léon Gambetta in 1881–2—but it was because he was his best friend from

In the traditional painter's pose—imitating his dear Velázquez in *Las Meninas*—Manet kept his elegant hat on, though his brush is ready to put color on his palette. Manet crudely sketched some details—the hand and the palette, for instance—in order to concentrate light and thought on the essentials: the eye, the brow, and the brush lit from the top—the fixed arrow ready to reach its mark.

childhood. And it was Manet himself who asked Henri Rochefort and Georges Clemenceau (a future prime minister of France who was then a radical member of the Chamber of Deputies) if they would be willing to pose for him. Neither man appreciated the result, yet both likenesses are surprising for their insight and truthfulness. (André Malraux, France's minister of culture under Charles de Gaulle, was mistaken when—in his passion to see Manet as the inventor of pure painting and thus implicitly the destroyer of the subject in painting—he wrote "for Manet to have painted Clemenceau, he had to resolve to put himself entirely into it, and almost nothing of Clemenceau.")

This astonishing portrait of Georges Clemenceau (1879–80, opposite), whose features—though spare—are powerfully expressive, apparently did not please its sitter. "My portrait by Manet?" the future Prime Minister is reputed to have said. "Very bad. I do not have it and therefore it does not bother me in the least. It is at the Louvre, and I myself wonder why they put it there!"

Women

In any event, Manet loved to paint women far more than he did politicians. More often than not, he showed them disguised, playing roles, recording their

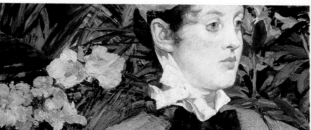

The actress Ellen Andrée (photograph below) enjoyed sitting for her painter friends. In *The Plum* (1878, opposite below), Manet put her in the

gestures as social archetypes. Early in his career, he had dressed the photographer Nadar's mistress in masculine Spanish costume and his own model Victorine as a toreador. In the 1870s, he proposed the portrait of the elegant Madame Guillemet, seated on a bench next to her husband in a jungle-like winter garden, the eroticism of which novelist Zola had just elaborated on in a famous scene in *La Curée* (*The Vicaress*, 1872).

For *The Plum* (1878), Manet re-created a café decor in the studio. His friend the actress Ellen Andrée posed for it (two years earlier, Andrée had been the model for Degas' *Absinthe*). A key compositional element, Andrée's fresh complexion is by no means that of an alcoholic! On the contrary, Manet delights in the savory pinks of the flesh and her dress. Degas' *Absinthe* is a social statement; *The Plum,* the depiction of a delectable reverie. The woman in *The Lady with the Fans*, disguised as an Algerian

naturalistic and very Parisian role of a young woman, perhaps a little tipsy, waiting in a café.

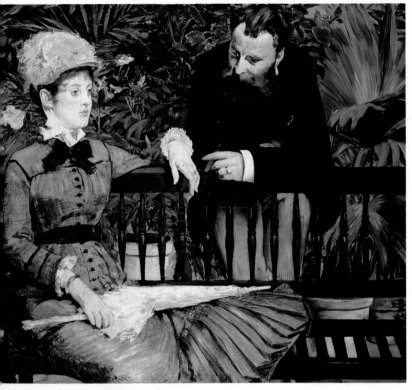

and set against a Japanese background, was Nina de Callias, an accomplished pianist whose musical, literary, and artistic salons were among the most brilliant in Paris.

Méry Laurent was Manet's closest woman friend during his last years. A lavishly kept woman, she loved to surround herself with luxury, but also with painters and writers, the most smitten being Mallarmé. Manet was enchanted with her gaiety, her health, and her

In *In The Conservatory* (1879, above and details opposite), Manet painted the portrait of a bourgeois couple, updating a traditional genre. The focus is on the two hands, duly ringed.

For this painting (1879–80, left), the singer Emilie Ambre posed as Carmen, her favorite operatic role. Full of enthusiasm for Manet's painting, she decided, on her first opera tour (1879–80), to take *The Execution of Maximilian* to the United States, where it was rather coldly received. Above is a sketch in watercolor done on graph paper in about 1880, doubtless rendered on the spot in a café.

elegance, and often painted her dressed in furs, her head covered with a toque or a large hat.

Pastels

During the last two years of his life, when illness made it difficult for him to undertake large works, Manet produced numerous small still lifes of fruits and flowers, but mainly he liked to make pastel portraits of his women visitors, pastel being a medium that was less tiring to work with and more rapid than oil.

He thus immortalized the various charms of Irma Brunner, "the lovely Viennese," and the Valtesse de la Bigne—women who lived off their charms; Madame Guillemet, who ran a business selling fancy lingerie; actresses such as Emilie Ambre and Jeanne Demarsy; and

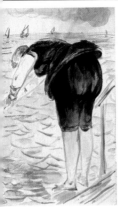

young sophisticates such as Suzette Lemaire, the daughter of a painter friend, and Isabelle Lemonnier, the sister-in-law of Georges Charpentier, a publisher of the naturalist writers and future champion of the Impressionists.

"Since 1878, Manet suffered attacks of illness and constant emotional upset," attested his friend Pierre Prins...It is odd, but the presence of a woman, no matter who she was, would help him regain his composure."

During the summer of 1880, Isabelle Lemonnier—one of Manet's favorite models—received a series of illustrated letters from the painter. The image at left is from one in which he imagines her diving. Below is her likeness from another letter.

Overleaf: Manet's elegant friends Irma Brunner (1880?, left) and Méry Laurent (1882, right).

First Dealer, First Collector

The dealer Paul Durand-Ruel, who had earlier been a specialist in the Barbizon School, "discovered" the paintings of Monet and Pissarro in London, where the two had sought refuge during the Franco-Prussian war of 1870. In January 1872, when he visited the Paris studio of Alfred Stevens in Paris—a successful society painter but also a very good friend to the Impressionists—Durand-Ruel had been particularly impressed by two of Manet's works from the 1860s—*Still Life with Salmon* and *Moonlight at Boulogne*—which Manet had left with his friend to attract a future buyer. (Until then, Manet had never really sold anything, although ten years had elapsed since his first success at the Salon.) The dealer became interested in the painter, and the next day returned to buy twenty-two of his works. Henceforth, it would be Durand-Ruel who would be his chief advocate.

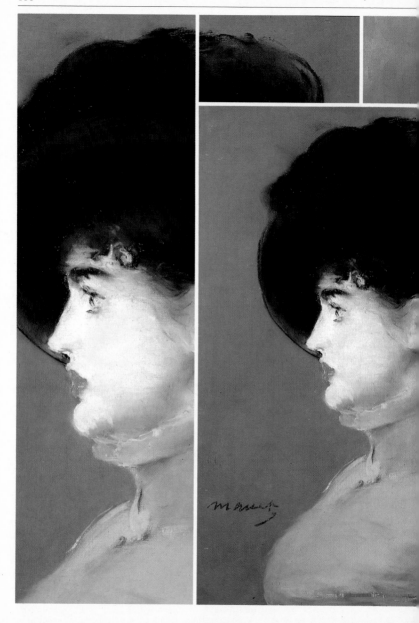

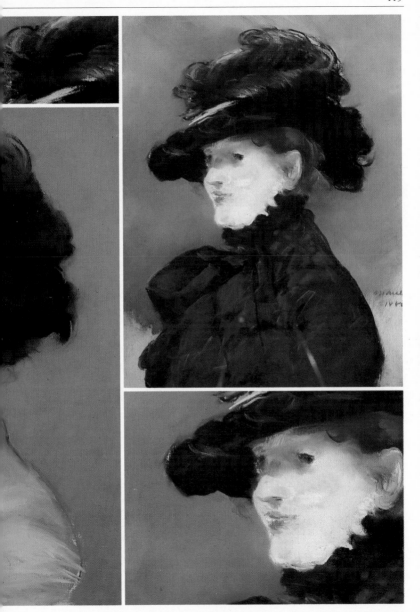

The principal collector of Manet's work while he was alive was neither a banker nor a wealthy bourgeois, but a man of the stage who had become famous and well-to-do. And, like Manet, he was a boulevardier. This was the baritone singer Jean-Baptiste

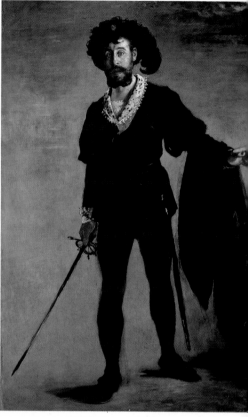

Faure. Faure possessed as many as sixty-seven works by Manet, among them *The Spanish Singer, Mlle. V… in the Costume of an Espada, Le Déjeuner sur l'Herbe, Lola de Valence, The Fifer,* and *The Railroad.* The era of Moreau-Nélaton and the Havemeyers—the two names we associate today with major collections of Manet's paintings—and public subscriptions for Manet's work was yet to come.

Jean-Baptiste Faure, the celebrated opera singer and collector of Manet's works, is shown here in a photograph and in an 1877 work by Manet from the ghost scene in *Hamlet.*

Stage Portrait

In 1877 Manet painted a portrait of Faure in the title role of the opera version of *Hamlet,* the vehicle that had

secured his celebrity status in 1868. Manet chose the most dramatic moment: the apparition of the ghost before Hamlet's hallucinating eyes.

In this work, Manet rediscovered the powerful blacks of his Spanish-style paintings of the previous decade, contrasting them with the harshly lit face illuminated by the stage footlights. It is one of the rare portraits where Manet—usually preferring tranquillity, if not downright indifference and absence, in the faces of his models—allowed a hint of expression to emerge.

"After having posed twenty times," Faure recollected, "I was obliged to leave to sing I don't know where.... Upon my return I found that the portrait had been altogether altered, with a blinking supernatural ground and legs that were no longer my own.

'These are not my legs,' I told him, surprised that my image only suited me by half. 'What does it matter to you!' [Manet replied,] 'I took them from a model who has finer ones than yours!' After a sourish correspondence, we became friends as back in the old days.... Because of him, I threw my lot with the die-hards in the matter of painting. He sent me [Edgar] Degas, [Camille] Pissarro, [Alfred] Sisley, Claude Monet, from all of whom I acquired so many works." This anecdote reveals many facets of Manet's character: his sense of freedom as a painter; the irrepressibly offhand manner with which he treated his only collector—of whose vanity he was certainly aware; his mocking wit; and, finally, his exceptional generosity toward his younger colleagues.

The critics and the cartoonists had a field day when the painting *Faure in the Role of Hamlet* was shown at the Salon of 1877. "The king of the die-hards wanted to make a portrait of the king of singers. The portrait is ridiculous," stated one. Drawings by Cham carried the captions like "Hamlet gone crazy, has himself painted by M. Manet" and "A portrait of a tadpole." This anonymous caricature (above) was accompanied by a pithy text: "M. Faure shrunk by M. Manet." The poor Faure must have suffered, though this makes his worth as a collector all the greater!

Masks and Costumes

One of the first paintings Faure bought of Manet's was *Masked Ball at the Opera,* painted in the spring of 1873,

the very year that this opera house on the Rue Le Pelletier, where Degas had also worked a good deal, disappeared in a fire.

It was a specific event Manet depicted—the famous annual masked ball, which took place at the end of March. There is no doubt that Manet was in attendance, but he associated it with a particular memory: the scenery of the first act of the naturalistic play by the Goncourt brothers, *Henriette Maréchal*. (This play had caused a scandal in 1865, the same year that the

Olympia did; it, too, was accused of vaunting a vulgar "modern realism.")

As in *Music in the Tuileries,* Manet introduced a few of his friends in this frieze of rakes in top hats, whom he had pose in his new studio on the Rue d'Amsterdam, in the heart of Paris. "The solitude where he had lived and worked came to an end," recalled Théodore Duret. "He received more frequent visits from a large number of men and women who made up Parisian society, who, drawn by his renown and the pleasure of his company, came to see him and, on occasion, agreed to be used as his models."

Thus it was that the author of these words posed for this painting, along with the collector Albert Hecht, the composer Emmanuel Chabrier, an intimate of Manet's and his wife's, and a few other now-forgotten painters. The identity of the "female dominoes" (masked women) or the scantily clad Columbines decked out in seductive

M*asked Ball at the Opéra* (1873–4) is more suggestive of a funeral than the expected devilish swirl, even though Manet made at least one preparatory sketch (above left) on the spot at Rue Le Pelletier.

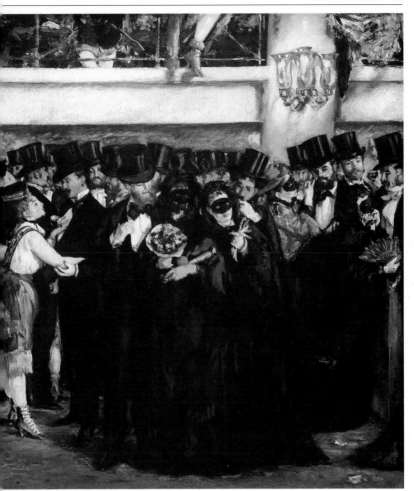

accessories is not known—all that is visible of one astride the balustrade at the top of the painting is her red boot. The contrast of the funereal garb worn by the men and the touches of color on the women and the harlequin must have amused Manet and recall to the viewer Gautier's contemporary lines: "Carnival clowns the garb now emulate / Wherein we grace the ball, and lie in state."

"The costumes merely break up the monotony of the background of black frock coats with some fresh floral tones."
Stéphane Mallarmé

Heroines of Modern Paris

Since *Masked Ball at the Opera* was deemed too naturalistic by the jury of the 1874 Salon, one should not be surprised to learn that in 1877 the jury also rejected *Nana*. This work was a full-length portrait of the type of woman to be found at the ball. If *Olympia* was perceived to be a Baudelairean prostitute, *Nana* was a contemporary tart, very Third Republic. She was painted during the winter of 1876–7, more than three years before the publication of Zola's novel of the same name. The work was doubtlessly named thus the moment Manet presented it to the Salon, as soon as Manet had learned of the title of the forthcoming novel of his erstwhile defender. "Manet was absolutely right to present us in his *Nana* one of the most perfect examples of this type of girl that his friend, our dear master, Emile Zola, is going to portray for us in one of his forthcoming novels," novelist Joris-Karl Huysmans declared.

Nonetheless, Manet's *Nana* is different from Zola's: Zola's character is clearly a vamp, while Manet's is simply a big-hearted girl who seems to like playing a role in her corset, waving her powder-puff. And for good reason!

Manet had one of his friends pose, the actress Henriette Hauser, a woman who was well known to all of Parisian gallant society. Once more, he had provoked the jury.

Hauser appears again in 1877, in a scene of a popular Parisian diversion: *Skating*. Here she is an elegant and stout visitor to the newest fashionable spectacle on the Champs-Elysées. Through his rough technique, Manet in his studio attempted to evoke from memory in his studio the nocturnal, fluttering spectacle and the whirling movement of the crowd and the skaters.

Café-Concerts

Among the prominent places Manet frequented were the cafés, restaurants, and music-halls where artists, writers,

For *Nana* (1877, opposite) and *Skating* (1877, below), Manet asked the actress and demimondaine Henriette Hauser to pose. In one work she is a spectator at the edge of the skating rink on the Champs-Elysées; in the other, she mimes a scene from a courtesan's life. This last work, deemed indecent, was turned down by the jury of the 1877 Salon, an act that prompted these words from Manet, recollected by Antonin Proust: "Nymphs offering themselves to satyrs is all right. A pretty woman in undress is forbidden!" He showed *Nana* in the window of a store on the Boulevard des Capucines, where she nearly provoked riots.

In *Nana*, thus baptized in 1877, well before the famous novel by Zola appeared in 1880, Manet repeated the theme of the courtesan, which had caused such a scandal with *Olympia*—only this time he chose a style that was closer to the naturalistic literature of the time. It may have been a sentence from Zola's *L'Assommoir* (*The Saloon*, published that year), in which Nana is first introduced as an adolescent, that inspired Manet: "Since the morning, she had spent hours in her chemise before the bit of looking glass hanging above the bureau;…she had the fine fragrance of youth, the bare skin of a child and of a woman."

and society people and the demimonde liked to go to see and be seen. These were places of pleasure and of lovers' meetings, but they also functioned as centers of intellectual and artistic exchange. "I attended neither Oxford nor Cambridge," recalled the Irish writer George Moore, who was in Paris studying art during those years, "but I attended the Nouvelle-Athènes,…the Académie des Beaux-Arts. No, not the official institution, but the real Académie Française: the Café."

During the 1870s, a tacit sharing of analogous subjects took place between Degas and Manet. Degas showed the active Paris, that of movement and work—the world of dancers, musicians, milliners, prostitutes, acrobats, laundresses, and other craftspeople and laborers who were not at all from his milieu. Manet, on the other

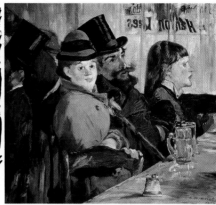

hand, usually chose to reflect a more familiar, more frivolous world, men and women in moments of tranquillity, gaiety, nonchalance, in search of small quotidian pleasures—out for an afternoon of rowing (*Boating*), drinking beer or listening to music (*At the Café, Girl Serving Beer*), flirting at a restaurant table (*At Père Lathuille's Restaurant*), reading a newspaper (*Reading*), or, as in his final masterpiece, *A Bar at the Folies-Bergère,* simply waiting for a customer.

To each his genius: The eye of Degas was searching; that of Manet registered the particular places of those slightly vulgar modern manners of the boulevard by using his sparkling wit, his admirable qualities as a painter, and his innate kindness toward others—"his tender skepticism," as Manet biographer Jacques-Emile Blanche would say—to produce authentic icons of modern life.

At the Folies-Bergère

In the winter of 1877–8, Manet had begun a large work for the Salon that depicted the Reishoffen Brasserie, a café-concert located between the Boulevard de Rochechouart and the Place Clichy. For reasons that are not known—though, as we have seen, Manet had

At the Café (1878, above), and inside a café (above left).

George Moore at a café, which he called "the real Académie Française."

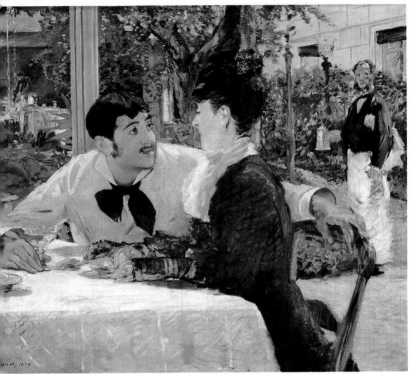

already cut up other major works—he divided this canvas into two parts and renamed them: The one on the right became *Girl Serving Beer,* the other, *At the Café.* Perhaps Manet, the great simplifier, had the impression that too many figures would dissipate the viewer's attention? If this was the case, he neatly avoided this stumbling block in his last great work, *A Bar at the Folies-Bergère,* painted during the winter of 1881–2, when he was already very handicapped by the disease (syphilitic locomotor ataxia) that would eventually cause his death.

For once it was not one of his women friends whom he asked to pose (two of them, however, can be discerned in

For Manet, Père Lathuille's, a garden restaurant on the Avenue de Clichy, had the advantage of allowing him to paint simultaneously a scene of Parisian life and figures out of doors.

the balcony: Méry Laurent in white and Jeanne Demarsy with the twins). No, this time, he borrowed a real serving girl from a bar at the Folies-Bergère. She came to pose in his studio, in front of a reconstituted bar on which he had placed a sumptuous still life of fruits, flowers, and bottles. The purpose of the mirror was to reflect the sparkling ambience of this café-concert, a pastime then very much in fashion, albeit slightly debauched—"the only place in Paris that stinks so sweetly of the

Taken at about the time Manet was executing his famous painting, this photograph is of the café-concert at the Folies-Bergère, a place known for its acrobatic spectacles and easy social intercourse.

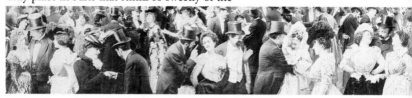

maquillage of purchased favors and the extremes of jaded corruption" (Huysmans). The serving girl, who was shown alone from the front—and, strangely, also from behind in the mirror—appears to be holding a conversation with a customer. Her flesh and bouquet of roses are like offerings, as if at the summit of the pyramid of the things to be tasted on the counter. She counters all of this potential temptation with a gaze that is both weary and absent. There is something poignant in this quintessential image of the Parisian universe that had been Manet's life, his world. The party was over. Farewell my beauty, farewell to life. Farewell to painting.

Manet chose to show not the crowd at the Folies-Bergère, but one of the three bars of the circular promenade,

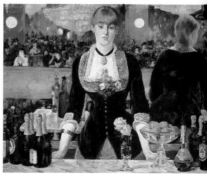

A Lively Studio

During his final years, when he was finishing *A Bar*, all of Paris filed through his studio, the atmosphere of which Blanche later described: "[Composer] Emmanuel Chabrier would make up sayings. Manet adored puns, something that has so much gone out of fashion. By five o'clock it was barely possible to find a seat next to the artist. On a small round iron table, which often appears in Manet's work, a waiter served mugs of beer and

described by Guy de Maupassant in his story *Bel-Ami* (1885): "A group of women awaited arrivals at one or another of three bars behind which, heavily made up and wilting, three vendors of refreshments and love held court."

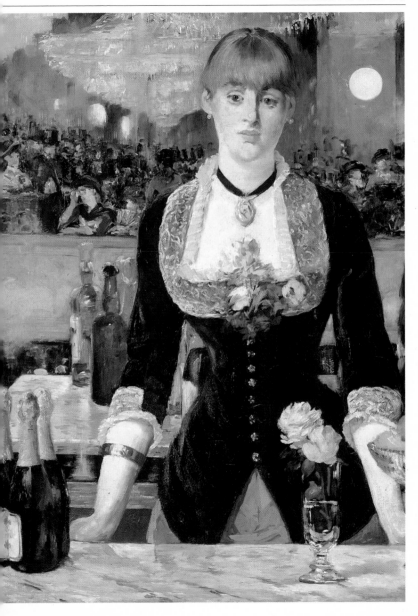

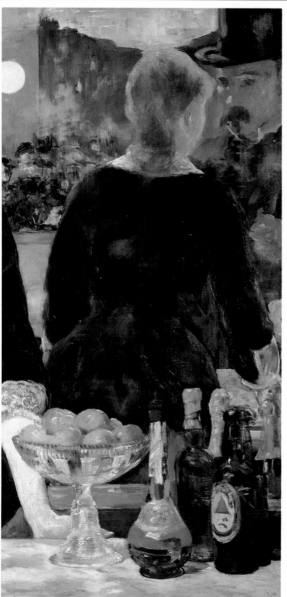

The serving girl's back in *A Bar at the Folies-Bergère* has generated a lot of speculation. Judging from her reflection in the mirror—in which one is able to see almost the entire crowded room—she is leaning toward a man who has no doubt given his order for a drink from the bar. Seen from the front, however, she seems to be more vertical and to be looking rather dejectedly at us, not her customer; in reality, the man reflected in the glass would hide her from our view. "M. Manet's *A Bar at the Folies-Bergère* bewilders the throng of visitors, who exchange puzzled comments concerning the mirage of this canvas… which is not quite right optically. The subject is modern enough…but what is the meaning of this lighting? Gas light, electric light? Not at all, it is a vague *plein-air*, a bath of wan daylight," wrote Huysmans. The faulty perspective and this aura of unreality were deliberate. They were the result of Manet having painted the girl—and the table and still life in front of her—in daylight in his studio, all the while superimposing the memory of the nighttime scene on his daytime observations.

apéritifs. The frequenters of the boulevard would come to keep their comrade company—he who could no longer go down to the Café de Bade…. After laborious, though short, sessions, Manet, who tired quickly, would stretch out on the low couch against the light of the window and contemplate what he had just finished painting, twisting his moustache and gesturing like a kid who would say: 'Nice, very nice!' [His guests] would laugh and menace him with [fabricated] fulminations from the Salon jury, which still was opposed to his work. Manet was no longer grieved by this, since by then 'his name was a flag'; he was the head of a school without a school. He was supported by a party that used him as a candidate to get him to sign up with those professions with revolutionary beliefs during the electoral period, to open the way to others who were 'more serious.' … His 'defective' masterpieces were covered with dust, in a cupboard where no one imagined turning them over, because one only went to see him for conversation. It was

Manet sent this illustrated letter (1880, above) to Isabelle Lemonnier offering her a drawing of a fruit from his garden accompanied by a poem he wrote in her honor.

thought (by Zola, at any rate) that he was searching for something…that others with more talent would find…. The 'defects' that separated him from the public were his essential qualities, the 'fatality' of his gift."

"Greater Than We Thought"

The pallbearers at Manet's funeral, which took place on 3 May 1883, were Antonin Proust, Emile Zola, Philippe Burty, Alfred Stevens, Théodore Duret, and Claude Monet. His old comrades from Montmartre were all there, painters of every bent. Degas followed Manet's funeral procession to the cemetery. "He was greater than we thought," he said.

Manet died at the age of fifty-one. His career as an artist had lasted scarcely more than twenty years, during which time his boisterous public image and his charm eclipsed his greatness as a painter, even in the opinion of the greatest thinkers. The noise of the boulevard died down. Slowly, the accolades began.

Overleaf: Sick and reclusive during the last year of his life, Manet was able to execute only pastel portraits and still lifes of fruits and flowers, which were then often given away to his friends. In the summer of 1882, the painter made spectacular use of the last roses and tulips in his garden at Rueil, placing them in a glass decorated with a dragon.

DOCUMENTS

Meetings with Manet

Everyone agreed that Manet was seduction itself. But his charm, his wit, his gaiety, and the elegance with which he hid his torments and his artistic obsessions could overshadow his genius as a painter.

Fair haired, smiling, this Manet
From whom grace shone every way—
Bearded, Apollonian
Subtle, gay and charming so
Had an air from top to toe
Of the perfect gentleman.
 Théodore de Banville

Early Years

Antonin Proust, Manet's oldest friend, quickly abandoned painting to become a journalist and a politician. Proust was Léon Gambetta's secretary, and then his minister of fine arts for a few months during the winter of 1881–2 when Gambetta was French premier. Manet painted Proust's portrait, portraying him as a very official personage, in 1880.

Manet was of average height and very muscular. Straight-backed, well-balanced, his loose-limbed, rhythmic gait gave his presence a special elegance. Though he often exaggerated his postures and affected the drawling speech of a Paris urchin, he could never be vulgar. You sensed his breeding. Beneath a broad forehead, his nose plunged straight down, while his

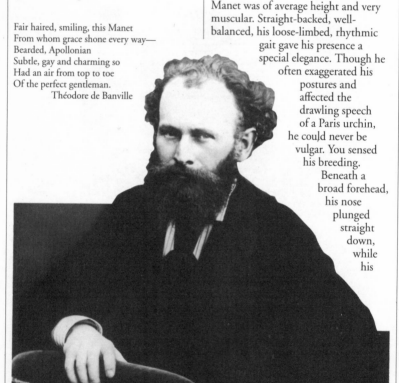

mouth curved up at the corners, giving him a teasing expression. His glance was bright, and his eyes, though small, were extremely mobile.

When he was quite young, he would fling back a head of long, naturally curly hair. At seventeen his hairline was already receding, but his beard had grown in, blurring the contour of his lips and leaving bare a smooth white chin. The lower part of his face softened, harmonizing with the fine graying hair that framed his forehead. Few men have been so attractive.

Despite his wit and his tendency to skepticism, he remained naive. He was surprised by everything and was amused by anything.

On the other hand, he took everything that had to do with art very seriously. On this point, he was intractable. His understandings were immovable, irreducible. He would allow neither contradiction nor even discussion.

Antonin Proust,
"*Edouard Manet, Souvenirs,*"
La Revue Blanche, 1897

Manet in Spain

In 1865, after the scandal of the Olympia, *Manet, deeply crushed, made a journey to Spain. It is there that he met Théodore Duret, the man who was to become one of his closest friends as well as his biographer.*

When the Salon was closed in the month of August, in order to secure a brief respite from persecution, he carried out his long matured project of a visit to Madrid. It was there that I made his acquaintance. The manner of our meeting was so remarkable and so typical of his impulsive character that I feel bound to relate the incident here.

I was returning from Portugal, through which I had travelled partly on horseback, and had arrived that very morning from Badajoz, after [rushing] for forty hours. A new hotel had just been opened in Madrid, in the Puerta del Sol, on the model of the large European hotels,—a thing hitherto unknown in Spain. I arrived worn out with fatigue and literally famishing of hunger. The new hotel where I had put up appeared to me a veritable palace of delight. The lunch to which I had sat down seemed like a feast of Lucullus. I ate with a sensation of luxury. The dining hall was empty except for a gentleman who was sitting some distance away at the same long table as myself. He, however, found the cuisine execrable. Every other minute he ordered some new dish, which immediately afterwards he angrily rejected as inedible. Each time that he sent the waiter away, I on the contrary called him back, and with ravenous appetite partook of all the dishes indifferently. Meanwhile I had paid no attention to my neighbour who was so difficult to please. When, however, I again asked the waiter to bring me a dish which he had refused, he suddenly got up, came near to where I was sitting and exclaimed angrily. "Now, sir, you are doing this simply to insult me, to make a fool of me,—pretending to relish this disgusting cooking and calling back the waiter every time that I send him away!" The profound astonishment that I displayed at this unexpected attack immediately convinced him that he must have made a mistake as to the motive of my behaviour, for he added in a milder tone, "You recognize me; of course, you know who I am?"

Still more astonished, I replied, "I don't know who you are. How should I recognize you? I have just arrived from Portugal. I nearly perished of hunger there, and the cuisine of this hotel seemed to me to be really excellent." "Ah, you have come from Portugal," he said, "well, I've just come from Paris." This at once explained our divergence of opinion as to the cooking. Realising the humour of the situation, my friend began to laugh at his fit of anger, and then made his apologies. We drew our chairs nearer to one another and finished our lunch together.

Afterwards he told me his name. He confessed that he had supposed that I was some one who had recognised him and wished to play a vulgar joke upon him. The idea that the persecution which he thought he had escaped by leaving Paris was about to begin again in Madrid had at once exasperated him. The acquaintance thus begun rapidly kindled into intimacy. We explored Madrid together. Naturally we spent a considerable time every day before the paintings of Velásquez in the Prado. At this time Madrid preserved its old picturesque appearance. There was still a number of cafés in the old houses of the Calle di Sevilla, which formed a general rendezvous for people connected with bull-fighting, toreros, aficionados, and for dancers. Large awnings were stretched across the street from the upper storeys of the houses, giving it an agreeable shade and comparative coolness in the afternoon. The Calle di Sevilla with its picturesque life became our favourite haunt. We saw several bull-fights,—Manet made sketches of them, which he used later for his paintings. We also

At *the Prado*, an etching after Goya.

went to Toledo to see the Cathedral and Greco's pictures.

There is no need to tell how everything that Manet saw in Spain, which had haunted his dreams for so long, fulfilled his utmost expectations. One thing, however, spoilt his pleasure,— the difficulty which he had experienced from the first, of accommodating himself to the Spanish mode of living. He could not fall in with it. He almost gave up eating. He felt an overpowering repugnance to the odour of the dishes that were set before him. He was in fact a Parisian who could find no comfort out of Paris. At the end of ten days, really starved and ill, he was obliged to return.

Théodore Duret
Manet, 1937

At the Manets, 1869–70

The Manets and the Morisots quickly became good friends. Mme. Morisot went with her daughters to the Thursday evenings hosted by Mme. Auguste Manet, which were attended by Edouard, his wife, Suzanne, and his brothers, Eugène and Gustave. There one met Baudelaire, Degas, [poet] Charles Cros, Zola, Astruc, and Stevens at whose home one made the acquaintance of Puvis de Chavannes. Bosc sang, accompanying himself on the guitar. Emmanuel Chabrier played with an unbridled exuberance the *Danse Macabre* of Saint-Saëns. Mme. Edouard Manet had a particular way of interpreting Chopin, her little hands with a light touch on the piano; there was a great deal of discussion....

After Denis Rouart
Berthe Morisot

At the Vernissage of the Salon of 1869

You will understand that my first concern was to make my way to Gallery "M." I found Manet, his hat over his eyes, looking bewildered; he begged me to look at his painting since he dare not himself. I have never seen such an expressive face. He laughed uneasily, declaring at one and the same time that his painting was very bad and that it would be very successful.

To me he is a decidedly charming person who pleases me immensely. His paintings, as usual, give the impression of strange, or even unripe, fruit. To me they are far from unpleasant. In the *Balcony* I am more odd than ugly. It seems that the epithet of "femme fatale" has gone the rounds of the sight-seers.

Berthe Morisot
Letter to her sister Edma
Morisot-Pontillon, 2 May 1869

Laughing with Manet

Your life strikes me as charming at this point;...chatting with Degas while watching him sketch, laughing with Manet, philosophizing with Puvis, strike me as things worthy of envy.

Edma Morisot-Pontillon
Letter to her sister Berthe

At the Café

George Moore, an Irish critic and novelist (1852–1933), came to Paris in 1873 to study painting, which he abandoned around 1876 to take up writing. His recollections of artistic Paris at the time are valuable. He very much admired Manet and worked actively to have his work known in Britain.

At that moment the glass door of the café grated upon the sanded floor, and Manet entered. Although by birth and by art essentially Parisian, there was something in his appearance and manner of speaking that often suggested an Englishman. Perhaps it was his dress—his clean-cut clothes and figure. That figure! those square shoulders that swaggered as he went across a room and the thin waist; and that face, the beard and nose, satyr-like shall I say? No, for I would evoke an idea of beauty of line united to that of intellectual expression—frank words, frank passion in his convictions, loyal and simple phrases, clear as well-water, sometimes a little hard, sometimes, as they flowed away, bitter, but at the fountain head sweet and full of light. He sits next to Degas, that round-shouldered man in suit of pepper and salt.... These two men are the leaders of the impressionist school.

George Moore
Confessions of a Young Man, 1972

At the Fernando Circus, 1876

*The Fernando Circus was frequented by painters who were taken by such spectacles of modern life. Degas made a famous painting of it in 1879 (*Miss Lala at the Cirque Fernando*), as did Toulouse-Lautrec and Seurat later on.*

This Manet, with his small head à la Henri III, the most seductive and witty of men, the one with the finest soul, M. Gervex told us.… Our first meeting? Let me see…1876—I was twenty-four years old. It took place at the Fernando Circus, the actual Médrano, two steps away from the Nouvelle Athènes Café where the painters taken with reality and the outdoors would meet. Manet, my elder by twenty years, was in the company of Chavannes and of Degas. He introduced me to them as the creator of *The Autopsy at the Hôtel-Dieu,* which they had seen at the Salon. Manet spoke to me congenially.

Henri Gervex
"Recollections of Manet"
Bulletin of Artistic Life
15 October 1920

Meeting in the Batignolles

One evening in October 1878, I was walking down the Rue Pigalle, when I saw coming toward me a man of youthful appearance, most distinguished, turned out with elegant simplicity. Fair hair, a light silky beard, gray eyes, a straight nose, flaring nostrils, gloved hands, a quick and springy step. It was Manet. I recognized him from his photograph, which had appeared in the *Galerie des Contemporains.*

I don't know what prevented me from accosting him and expressing my admiration to him.… It was around six o'clock. I followed him for some time. … A little later, when I knew him, I told him of this reverential shadowing. "I am sorry that you didn't accost me," he told me, "it would have given me pleasure to know another partisan in the army!" (The young painter was then doing his military service).

Manet had a great success at the Salon of 1880. The jury was unsure, however, whether to award him a second medal, and in the end, did not give it to him.

Georges Jeanniot
"In Memory of Manet"
La Grande Revue
10 August 1907

At the Louvre: "He Said Nothing and I Heard Everything"

Manet never found the time to paint Gambetta's portrait.

One morning when he was expressing his annoyance about his setback, we decided to distract him, to go to the office of Ronchaud, who at the time was the Louvre's director. There, Manet silently leafed through a collection of drawings by Filippo Lippi, Botticelli, Perugino, Mantegna, and Carpaccio, among others.

"I am indebted to you," he told Gambetta while leaving, "for having spent one of the most delightful mornings of my life. It seemed to me that I was as much with them as with you."

"My own joy," retorted Gambetta, "was above all to have brought you pleasure, my dear friend."

We left Manet on the Place Saint-Germain-l'Auxerrois.

"It would be impossible for me to

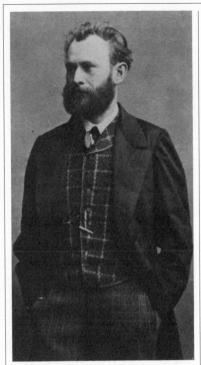

"His hair and beard are light chestnut brown; his eyes, narrow and deep set, have a boyish liveliness and fire; his mouth very characteristic, thin, mobile, a trifle mocking at the corners."
Emile Zola

imagine," Gambetta told me, "anything more eloquent than the eye of Manet, leafing through those drawings in that collection at the Louvre. He said nothing and I heard everything."
Antonin Proust
Edouard Manet, Recollections
1897

Manet Ill

Painter and engraver Pierre Prins had been close to Manet since the 1860s. He married Fanny Claus, the young violinist standing next to Berthe Morisot in The Balcony.

Ever since the first attack of paralysis that had knocked him down in his studio in 1878, Manet suffered attacks of illness and constant emotional upset. It was then that he felt "done for." An expression of his that I heard I don't know how many times, he was so haunted by it. It is odd, but the presence of a woman, no matter who she was, would help him regain his composure. Poor Suzanne had a lot to put up with....

The tale that he told to his intimates —that he had been the victim of a snakebite on the foot in the Brazilian forest during his voyage there when he was eighteen years old—no longer held up. The ataxia that had manifested itself by then had an origin that was all too recognizable.... Too subtle to let himself be taken in by kind words, he was too nervous and too clairvoyant not to bitterly suffer the defeat that he dreaded. He felt first off struck down in his art and that was the hardest of all.... His brush "disobeyed"!... Anguished, feverish before the canvas, undermined to his core.... How could one overcome that? His moodiness has been alluded to. I witnessed it…but he suffered it more than anyone. Then he would isolate himself "like a sick cat," he said, with a wan smile, rather than display his weakness—altogether relative but which he exaggerated—during visits that were sometimes unbearable, though he always welcomed them, a kind word on his lips.
Pierre Prins
Recalled by his son in *P. Prins*
1949

Manet's Writings

Manet was not one of those painter-writers who left behind their private journals or theoretical tracts. His letters are lively and charming, but they never discuss his work. On the other hand, he spoke a great deal, and his remarks were documented by his friends and by journalists.

From an 1880 letter to Mme. Guillemet.

From Rio de Janeiro to His Mother, When He Was Seventeen

5 February 1849

Dear Maman,

We have finally anchored at Rio after two months at sea and a lot of bad weather....

The city is fairly big, though the streets are rather small; for a European who is somewhat artistic they offer a particular cachet; one doesn't meet in the street anyone but Negroes and Negresses; the Brazilian men go out little and the Brazilian women even less;... In this country, all the Negroes are slaves; all these wretched ones look as if they had been brutalized; the power the whites have over them is extraordinary; I saw a slave market, it was a revolting spectacle; the Negroes' outfit is limited to pants, sometimes a cloth jacket, but because they are slaves, they aren't allowed to wear shoes. The Negresses are for the most part naked to the waist, some of them have a scarf tied around their neck and draped over their chest, they are generally ugly, though I saw some who were rather pretty;... Some of them wear turbans, others arrange their kinky hair rather artistically, and almost all wear skirts bedecked with enormous flounces.

As for the Brazilian women, they are generally very pretty; they have magnificent black eyes and similarly dark hair;...they never go out alone, they are always followed by a Negress or they are accompanied by their children....

We were unable to find a drawing master in Rio; thus, our commander urged me to give lessons to my comrades, so now I am elevated to the post of drawing master; it must be said that during the crossing I made myself

A fter his trip to Spain, Manet made these etchings based on Velázquez paintings.

such a reputation that each of the officers and teachers asked me for a likeness, and the commander even asked for his as a gift. I was delighted to fulfill all requests, in such a way that everyone was pleased.

Your respectful son,
Edouard Manet

From Spain to Fantin-Latour, Summer 1865

I *am* sorry that you aren't here, for what joy you would have to see Velázquez, who, alone, is worth the trip. The painters from every school, who fill the Museum of Madrid and who are well represented there, all seem fakers next to him. He is the painter of painters. He didn't surprise me, though he enthralled me. The full-length portrait that we have at the Louvre is not his. Only the Infanta cannot be contested....

The most astonishing piece of this splendid work, perhaps the most astonishing piece of painting that has ever been achieved, is the work shown

in the catalogue: *Portrait of a Famous Actor at the Time of Philip IV.* The background disappears: It's just air that surrounds the man, all dressed in black and animated. And *The Weavers*, the beautiful portrait of Alonzo Cano, *Las Meninas*...an extraordinary work as well! The philosophers, what extraordinary pieces! All the dwarfs; one above all, seated frontally, his fists on his hips: a choice painting for a true connoisseur. His magnificent portraits; you would have to enumerate all of them; there are only masterpieces....

And Goya! All the more strange compared with the master [Velázquez] whom he imitated too much, in the sense of the most servile imitation. Even so, a great liveliness. There are two

beautiful equestrian portraits of his at the museum, done in the manner of Velázquez; rather inferior all the same. What I have seen of him so far hasn't pleased me enormously. I have to see in the coming days, a magnificent collection of his work at the Duke of Ossuna's.

I am sorry the weather is rather vile this morning, and I fear that the bullfight that should take place this evening, which I am pleased to attend, will be put off. And then? Tomorrow, I go to Toledo. There, I will see El Greco and Goya, who are very well represented, so I have been told.

Madrid is a pleasant city, full of distractions. The Prado, a charming walk, is covered with pretty women, all in mantillas, which gives them a unique look. In the streets, there are many costumes: the bullfighters also have an odd city costume.

To Suzanne Manet During the Siege of Paris, 1870

23 October 1870
The newspapers have just announced that on Friday the Parisian army made a major attack on the enemy positions. They fought all day long. I think the Prussians have lost a lot of lives. On our side the losses are less considerable, even though poor Cuvelier, Degas's friend, was killed, and Leroux was wounded and, I think, taken prisoner. We're starting to get fed up with being quarantined and deprived of all communication, since it's been a month since we've had any news from you....

For a long time, my dear Suzanne, I was looking for your photograph. I finally found it in the album on the table in the salon and I can sometimes look at your kind face. Last night I awoke thinking that your voice was

Q*ueue at the Butcher Shop*, an etching from 1870–1.

calling me. The people who have remained in Paris see each other very

little. One is reduced to an enormous selfishness,... Otherwise every day we await some great event that will break the iron barrier that surrounds us. We count very much on the province

because we cannot massacre the little army that we have. Those Prussian rascals are capable of taking us through famine. I had asked to be the attaché to the staff of General Vinoy. I wasn't able to obtain the post. I am sorry about it, since I would have been able to assist in all their maneuvers....

Farewell, my dear Suzanne.

I embrace you as I love you.

To Eva Gonzalès

19 November 1870

Dear Mademoiselle Eva,

One of our besieged friends asked me lately how I endured your absence, since the admiration and friendship I hold for you is of such public renown. Allow me to answer you directly;... of all the deprivations this siege imposes upon us one of the most serious is that I am no longer able to see you;... for two months I haven't had news from my poor Suzanne, who must be very worried although I write her very often—we are all soldiers here.... Degas and I are in the artillery as voluntary gunners. I am counting that on your return you will do my portrait with my large artilleryman's cloak. Tissot was glorious in the Jonchères affair, Jacquemart was there, Leroux was seriously wounded at Versailles, the poor Cuvelier killed; my brothers [and] Guillemet are in the battalions of the National Guard and are just waiting to go the front lines.... My soldier's kit is filled with my paintbox, my country easel, everything I need so that no time is lost and so I will be able to benefit from the facilities that I find everywhere. Many cowards have left, alas, among them our friends Zola, Fantin, etc.... I think I will give them a hard time on their return.

To Berthe Morisot

10 June 1871

Dear Mademoiselle,

We have been back in Paris for a few days and the ladies have asked me to convey my greetings to you and to Mme. Pontillon, where you are no doubt staying.

What terrible events [the Commune and the repression of the Commune] and how are we going to get through them? Everyone is transferring the blame to his neighbor, and in effect all of us have been accomplices to what has taken place:… Here we are all on the verge of ruin; we all will have to endeavor to make the most of our work.

Eugène went to see you in Saint-Germain; you had gone out that day. I learned with pleasure that your home in Passy had been spared. I also noticed today this poor Oudinot, who had his hour of power. What a fall! I think, Mademoiselle, that you won't remain long in Cherbourg. In any case, everyone is returning to Paris, it's impossible to live anywhere else.

Comments on Art

Manet's only writing on art was the preface to a booklet accompanying his exhibition at the Alma Pavilion, at the gates of the Universal Exposition of 1867—and it was more of a tactical defense than an aesthetic manifesto. He was, however, a brilliant conversationalist, and a few of his comments have been gathered here.

Since 1861 Manet has been exhibiting, or trying to exhibit.

This year he has decided to show the sum total of his works to the public.

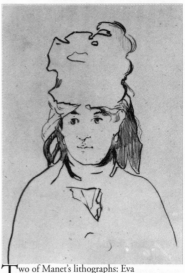

Two of Manet's lithographs: Eva Gonzalès (1870, top) and Berthe Morisot (1872–4, above).

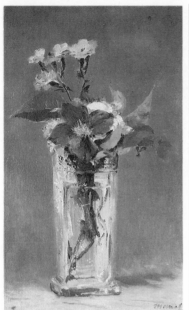

Pinks and Clematis in a Crystal Vase (1882?). Antonin Proust remembered Manet saying, "A painter can say everything with fruits and flowers, or with clouds only…. I would like to be like the Saint Francis of the still life."

Manet received an honorable mention when he first exhibited at the Salon. But since then he has seen himself rejected by the jury too often not to think that, if an artist's beginning is a struggle, at least one might fight with equal weapons. That is to say one must be able also to exhibit what one has done.

Without that the artist would be all too easily shut up in a circle from which there is no exit. He would be forced either to stack his canvases or roll them up in a hayloft.

It is said that official recognition, encouragement, and rewards are actually a guarantee of talent in the eyes of a certain part of the public; they are thereby forewarned in behalf of or against the accepted or rejected works. But, on the other hand, the painter is assured that it is the spontaneous impression of this same public that motivates the chilly welcome the various juries give his canvases.

In these circumstances the artist has been advised to wait.

To wait for what? Until there is no longer a jury?

He has preferred to settle the question with the public.

The artist does not say, "Come and see faultless work," but rather, "Come and see sincere work."

This sincerity gives the work a character of protest, albeit the painter merely thought of rendering his impression.

Manet has never wished to protest. It is rather against him who did not expect it that people have protested, because there is a traditional system of teaching form, technique, and appearances in painting, and because those who have been brought up according to such principles do not acknowledge any other. From that they derive their naive intolerance. Outside of their formulas nothing is valid, and they become not only critics but adversaries, and active adversaries.

To exhibit is for the artist the vital concern, the sine qua non; for it happens that after looking at something you become used to what was surprising or, if you wish, shocking. Little by little you understand and accept it.

Time itself imperceptibly works on paintings and softens the original harshness.

To exhibit is to find friends and allies for the struggle.

Manet has always recognized talent wherever he found it and has presumed neither to overthrow earlier painting nor to make it new. He has merely tried to be himself and not someone else. Besides, Manet has found important encouragement and has been able to see how much the judgment of men of real talent is daily becoming more favorable toward him. Therefore it is now only a question for the painter of gaining the good will of the public which has been turned into a would-be enemy.

Manet's preface to his May 1867 exhibition catalogue

We're in a pitiful state. Who was it who said that drawing was the handwriting of the figure? The truth is that art must be the writing of life. In short, at the Ecole des Beaux-Arts, one does beautiful work, but dirty business.

Manet
Comments made at Couture's studio, as recalled by Antonin Proust, 1897

On the subject of the expression "Impressionism," which did not arise, as M. Benedite wrote, from a work of Claude Monet's exhibited under the title *Impression*, but which arose from our discussions of 1858, when he volunteered: "An artist must be spontaneous. That is the right term. But to have spontaneity, he must be the master of his art. Experimentation never leads anywhere. You have to translate what you feel, but translate instantaneously, if you will. One speaks of the good retort when it is too late. But one never speaks of the staircase of the mind. Of the countless people who

seek to climb it but never reach the top, so difficult is it to climb its steps. Invariably, in fact, one notices that what one did one day is no longer consistent with what one does the next."

Manet, as recalled by Antonin Proust

I worry very little about what could have been said on art. But if I had to give an opinion, I would formulate one thusly: Everything that has the soul of humanity, everything that has the soul of contemporaneity is interesting. Everything that is deprived of it is worthless.

Manet, as recalled by Antonin Proust

I came back to see him during my stay and he told me things like this: Concision in art is a necessity as well as an elegance; a man who is concise makes you think, a verbose man bores you. Always move in the direction of concision. In a figure look for the highest light and the deepest shadow, the rest will come quite naturally: often it's nothing at all. And then, cultivate your memories; nature will never give you anything but hints—it's like a railing that keeps you from falling into banality. You must constantly remain the master and do as you please. No tasks! No, no tasks!...

Color, Manet went on, is a matter of taste and sensibility. For instance, you must have something to say, otherwise good night. You are not a painter if you don't love painting more than anything else, but it is not enough to know your métier, you must also be moved. Knowledge is all very well, but for us, you see, imagining matters more.

Georges Jeanniot
"In Memory of Manet"
La Grande Revue, 10 August 1907

When he was secluded during the summer of 1880, next to the hydrotherapy clinic where he was being treated for his locomotive ataxia, Manet wrote friends charming letters adorned with watercolors. Three of these melancholy missives were addressed to Isabelle Lemonnier. In the letter above, two flags celebrate the amnesty of the Communards on 14 July, with these words: "I will no longer write you, you never answer me." Under the cat above right: "This is a little hello in passing, I would like to receive mail every morning." Over the rose he has written: "Decidedly, either you are very busy, or you are very cruel. Still, I don't have the courage to hold it against you."

Olympia: Scandals and Triumphs

"Like a man who has fallen in the snow, Manet has made an impression on public opinion," wrote Champfleury to Baudelaire about the Olympia at the Salon of 1865.

1428

This cartoon by Cham appeared in *Le Charivari* on 14 May 1865. It was called "Manet: 'The Birth of the Little Slave Trader,'" and the legend read: "M. Manet has taken the matter too literally: what a bouquet of flowers! The notices were in the name of Mother Michel and her cat [a popular French song]."

A Succès de Scandale

The clamor set off by the *Olympia* and the *Jesus Mocked* added to the previous noise made by the *Déjeuner sur l'Herbe*, gave to Manet the kind of notoriety that no other painter had had before. Cartoons of all kinds, newspapers of all stripes, had set about with such persistence to cover him and his works that he soon acquired universal renown. Degas could say without exaggeration that Manet was as famous as Garibaldi. When he went out on the street, passers-by turned around to watch him. When he entered a public place, his arrival caused a stir, one or another singling him out as an odd creature. A young man might have been contented to be so noticed, but the public attention, in the form that it was given, soon destroyed whatever satisfaction might have been enjoyed by the man who received it.

Théodore Duret
Manet, 1906

If the canvas of the *Olympia* was not slashed and destroyed, it is only because of the precautions that were taken by the administration.… One evening, leaving the Salon, we entered the Imoda ice-cream parlor, at the top of the Rue Royale. The waiter brought the papers. "Who asked for newspapers?" said Manet. After a long silence, we returned to his studio;… I never saw Manet more sorrowful as on that day.

Antonin Proust
Edouard Manet, Recollections
1897

It is understandable why Manet did not want to see the newspapers, in light of what follows.

A Short Anthology of Insults Received by *Olympia* at the Salon of 1865 by the Most Recognized Critics of the Period

These terrible canvases, challenges to the mob, pranks or parodies, what can I say?… What's this yellow-bellied Odalisque, this vile model picked up who knows where, and who represents Olympia? Olympia? What Olympia? A courtesan, no doubt. No one will reproach M. Manet for idealizing mad virgins, when it's he who paints indecent ones.

Jules Claretie

Olympia can be understood from no point of view, even if you take it for what it is, a puny model stretched out on a sheet. The color of the flesh is dirty…. The shadows are indicated by more or less large smears of blacking…. We would still forgive the ugliness, were it only truthful, carefully studied, heightened by some splendid effect of color…. Here there is nothing, we are sorry to say, but the desire to attract attention at any price.

Théophile Gautier

I must say that the grotesque aspect of her expression is the result of two factors: first, an almost childish ignorance of the first elements of drawing, then a bent for an inconceivable vulgarity.

Ernest Chesneau

The mob, as at the Morgue, crowds around the spicy *Olympia* and the frightful *Ecce Homo* by Manet. Art sunk so low does not even deserve reproach.

Paul de Saint-Victor

Two years later, Olympia *found in Emile Zola a brilliant defender, profoundly influenced by his discussions with Manet in his studio.*

In 1865 Manet was again accepted at the Salon; he exhibited a *Christ Mocked by the Soldiers* and his masterpiece, his *Olympia*. I said masterpiece, and I will not retract the word. I maintain that this canvas is truly the painter's flesh and blood. It is all his and his alone. It will endure as the characteristic expression of his talent, as the highest mark of his power. In it I read the personality of Manet and when I analyzed the artist's temperament I had before me only this canvas which sums up all the others. Here we have, as the popular jokers say, an Epinal print. Olympia, reclining on the white sheets, is a large pale spot on the black background. In this black background are the head of a Negress carrying a bouquet and the famous cat which has entertained the public so much. Thus at the first glance you distinguish only two tones in the painting, two strong tones played off against each other. Moreover, details have disappeared. Look at the head of the young girl. The lips are two narrow pink lines, the eyes are reduced to a few black strokes. Now look closely at the bouquet. Some patches of pink, blue, and green. Everything is simplified and if you wish to reconstruct reality you must step back a bit. Then a curious thing happens. Each object falls into its proper plane. Olympia's head projects from the background in astonishing relief, the bouquet becomes marvelously fresh and brilliant. An accurate eye and a direct hand performed this miracle. The painter worked as nature works, in

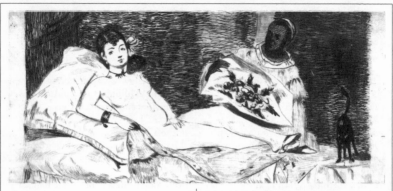

An etching and aquatint of *Olympia* (1867).

simple masses and large areas of light, and his work has the somewhat rude and austere appearance of nature itself. In addition there is a personal quality; art lives only by prejudice. And this bias is found in just that elegant austerity, that violence of transitions which I have pointed out. This is the personal accent, the particular savor of his work. Nothing is more exquisitely refined than the pale tones of the white linen on which Olympia reclines. In that juxtaposition of these various whites an immense difficulty has been overcome. The child's body itself is charmingly pallid. She is a girl of sixteen, doubtless some model whom Edouard Manet has quietly copied just as she was. And everyone exclaimed that this nude body was indecent. That's as it should be since here in the flesh is a girl whom the artist has put on canvas in her youthful, slightly tarnished nakedness. When other artists correct nature by painting Venus they lie. Manet asked himself why he should lie. Why not tell the truth? He has introduced us to

Olympia, a girl of our own times, whom we have met in the streets pulling a thin shawl of faded wool over her narrow shoulders. As usual the public took good care not to understand what the painter wanted. There are even people who have looked for a philosophical meaning in the painting. Others, less restrained, would not have been displeased to find an indecent intention.

And tell them with your voice raised, dear master, that you are not at all what they imagine, and that for you, a picture is but an opportunity for analysis. You wanted a nude, and you took Olympia, the first to come along; you wanted bright, luminous patches, and the bouquet served; you wanted black patches, and you added a black woman and a black cat. What does all this mean? You hardly know, nor do I. But I do know that you succeeded admirably in creating a work of painting, and of great painting, and in vigorously translating into a special language the verities of light and shade, the realities of people and things.

Emile Zola
A New Style of Painting
1867

Monet, *Olympia,* and the Museum

After Manet's death, in 1890, Monet would spend almost a year fighting to have Olympia *purchased by a group of artists and connoisseurs; he then offered the work to the state.*

Monsieur le Ministre,

In the name of a group of sub-scribers, I have the honor of offering to the state Edouard Manet's *Olympia.*

We are certain that we represent a great number of artists, writers, and collectors, who have long recognized the considerable place in the history of this century held by the painter who was prematurely removed from his art and his country....

The great majority of those who are interested in French painting agree that Edouard Manet's role was useful and decisive. Not only did he play an important individual part, he was also the representative of a great and fruitful evolution.

It thus appears impossible to us that such a work does not belong in our national collections, that the master is denied entrance where his pupils have already been admitted. In addition, we have noted with concern the incessant movement of the art market, the competition from America, and the easily foreseen departure for another continent of so many works of art that are the joy and the glory of France. We wanted to retain one of the most characteristic canvases of Edouard Manet, one where he appears in full victorious struggle, as master of his vision and of his craft.

It is the *Olympia* that we place in your hands, Monsieur le Ministre. Our desire is to see it take its place in the Louvre, when the time comes, among the productions of the French school. If regulations preclude its immediate entry, we believe that the Musée du Luxembourg is the obvious choice to receive the *Olympia,* and to keep it until the question can be reconsidered.

> Monet to Armand Fallières
> Minister of Public Education
> 7 February 1890

From Sacred Horror to the Wrapped Gift

Olympia shocked, aroused a sacred horror, imposed herself, and triumphed. She was a scandal, an idol, a public presence, and a powerful skeleton in society's closet. Her head is empty; a black velvet string isolates it from the essence of her being.... A bestial vestal virgin consecrated to the nude absolute, she bears dreams of all the primitive barbarism and animal ritual retained and hidden in the customs and practices of urban prostitution.

> Paul Valéry
> *Triumph of Manet,* 1932

The last impediment to utter naked-ness, with the exception of the jewel at her wrist and the mules ready to leave her feet: the neck band—hardly more than a thread—whose knot, as neat as the tie on a gift package, above the rich offering of the two breasts, forms a bow to be undone easily by pulling an end.

More than an ornament, this bauble, which perhaps for Manet was nothing more than a capricious drawing breaking up the whiteness of the nude, is for us the needless detail which sticks and which makes *Olympia* exist.

> Michel Leiris
> *The Ribbon Around Olympia's Neck*
> 1981

Visits to the Studio

Manet worked in seven studios, the most important being on the Rue Guyot, behind the Parc Monceau. It was there that Baudelaire and Zola came to see him. Then he moved into a succession of studios in the new Europe quarter, near the Saint-Lazare railroad station. From 1870 to 1878, he was on the Rue de Saint-Pétersbourg (numbers 51 and 4), and finally in 1878 he moved to the Rue d'Amsterdam (number 70, then 77), where he remained until his death in 1883.

Zola Posing in the Studio

I recall those long hours of sitting. In the numbness that overtakes motionless limbs, in the fatigue of gazing open-eyed in full light, the same thoughts would always drift through my mind, with a soft, deep murmur. The nonsense abroad in the streets, the lies of some and the inanities of others, all that human noise which flows as worthless as foul water, was far, far away.... At times, in the half-sleep of posing, I would watch the artist, standing before the canvas, face tense, eye clear, absorbed in his task. He had forgotten me, he didn't know I was there, he was copying me as he would have copied any human animal, with an attention, an artistic awareness, the like of which I have never seen.... All about me, on the walls of the studio, were hung those characteristically powerful canvases the public has not cared to understand.

Emile Zola
"My Salon," 23 May 1868

Manet in His Studio

At the entrance the artist came toward us, smiling affably and offering his hand in friendly fashion. We went into the hall, a large room paneled in dark antique oak with a ceiling of beams alternating with dark-colored coffers. A clear, soft, unvarying light enters through the windows overlooking the Place de l'Europe. The railroad passes close by, giving off plumes of white smoke which swirl in the air. The ground, continually shaken, trembles underfoot and shudders like the deck of a ship at sea. In the distance, the view

Detail from Henri Fantin-Latour's *A Studio in the Batignolles* (1870).

extends down the Rue de Rome, with its attractive ground-floor gardens and imposing houses. Then, on the heights of the Boulevard des Batignolles a somber dark hollow: it is the tunnel, an obscure and mysterious orifice devouring the trains which plunge under its vault with a sharp whistle.

On the walls were some of the painter's works. First of all the famous *Déjeuner sur l'Herbe*,

Drawing by Manet of visitors to his studio in 1876.

is something altogether remarkable on this easel at the foot of the oak staircase which leads up to the tribunal, where one once judged the moves when this magnificent atelier was a fencing school....

This canvas, which was destined for [the celebrated opera singer Jean-Baptiste] Faure, depicted the corridor of the Opera the night of a masked ball. That is the very work. Between the

rejected by the jury which stupidly did not understand that this is not a naked woman, but a woman undressed, which is quite different. Then the paintings exhibited on other occasions: the *Music Lesson*, *The Balcony*, *Olympia* with her Negress and her strange black cat which is certainly a close relative of Hoffmann's famous Mürr.... Then a *Seascape*, the sketch of two women seated in the middle of a field, surrounded by a village, a portrait of a woman and an exquisite *Punch*, pluckily seated.

But we now come to the new. There

massive pillars of the amphitheater wall, where the swells stand *en espalier*, and the lobby entrances separated by the legendary red velvet panels, there ebbs and flows a tide of black cloth on which floats an occasional Pierrette or *débardeuse* ["stevedorette"]....

Groups form in diverse attitudes. An impudent Gavroche, a blossom sprung from two gutter cobbles and—mystery of mysteries—lovely as a Grecian statue, in a state of undress to challenge the Sixth Commandment, pantalooned in a red velvet rag no bigger than a man's hand, with plenty of buttons to

be sure, and with cap set at forty-five degrees on her powdered tangle of hair, leads a troupe of white-tied revelers. There they all are, alight with Corton and truffles, with moist lip and sensual eye, with gold chains across their vests and rings set with gems on their fingers. Hats tilted back with an air of conquest: they are rich, that is clear…and they have come to enjoy themselves.

Perhaps there is not all this in the painting; perhaps there is more besides? At any rate, it is a work of high merit, alive, thoughtful, and admirably rendered. We shall see, at the next Salon, whether the public is of my opinion.

Fervacques
Le Figaro, 27 December 1873

T his portrait of Eva Gonzalès was probably painted in Manet's studio, where she was both model and student.

The Ateliers, 1875–83

I must have been thirteen or fourteen years old when I was taken to see Manet's studio, his first studio on the Rue de Saint-Pétersbourg, and which overlooked the middle of the Europe bridge. It was a salon with brown and gilded woodwork, a dentist's waiting room. On the wall, a canvas depicting M. and Mme. Astruc, playing the mandolin. We were invited to see a portrait of Desboutin.

Was it this time, or later, that I saw on the easel *The Laundry*, then altogether fresh, and dazzling in its light, of a blue so bright and so gay, that it made one want to sing?…

How could Manet work in this room so filled with sunlight? Is this where he completed *The Laundry*, *The Railroad*, *Argenteuil?* "The outdoor school" was often held indoors.…

The second studio on the Rue de Saint-Pétersbourg was the headquarters of important political meetings. During the day it received northern light, it was common and cold, in the rear of a courtyard where a number of artists lived.… In front of Manet's door, there were a few flowerpots and green tubs filled with laurel, just as on the terraces of the cafés during that period. A great deal of promiscuity prevailed among the neighbors, but after the studio session, everyone met at Manet's.

I still see him leaning on his cane with a leaden tip, maintaining his balance with difficulty on his rubber heels. He prided himself on his handsome foot, dressed in "English boots"; he often wore a pleated and belted Norfolk jacket, like an English sportsman. He hated the dauber's style. In a corner of the entryway, flopped

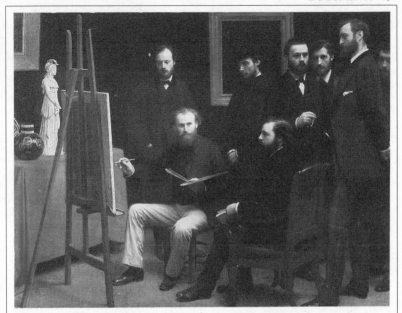

Surrounding Manet in Fantin-Latour's celebrated *A Studio in the Batignolles*, from left to right, are the German painter Scholderer, then Renoir, Astruc, Zola, the musician Edmond Maitre, Bazille, and finally Monet.

on the red sofa, were Albert Wolff, Aurélien Scholl, boulevardiers and demimondaines gathered around him....

The studio of 77 Rue [d'Amsterdam] was in no way that of the man who represented a master whose name was to dominate the end of the 19th century and the beginning of the 20th. A shed for forgotten canvases, most of them rolled up, it resembled those of my comrades who seemed to work, but who in fact received women. A few rare pieces of furniture, picked up here and there, a restaurant buffet, where the girl with the blue bodice leaned her hands in *Bar at the Folies-Bergère*, a few vases of flowers, liter bottles, flasks of liqueurs, a few bottles of champagne on the table where the two lovers sat for *At Père Lathuille's Restaurant*; the footed mirror in *Nana*, a zinc tub. On the easels, a few pastels, of George Moore and Méry Laurent, the friend of Henry Duprey and of Mallarmé, Manet's daily visitor, at the hour when one came to talk and laugh. On the chairs, a silk corsage, a hat, which after the model's departure, Manet copies with effort and diligence so as "to make it stay on the head." There is nothing more difficult to draw than a top hat, Manet used to say....

Jacques-Emile Blanche,
in *Remarks of a Painter from David to Degas*, 1919

The Triumph of Manet

Even though the established art critics and journalists were always relatively severe to the painter, Manet had the good fortune to attract, both in the course of his life and after his death, other remarkable writers: Charles Baudelaire, Emile Zola, Stéphane Mallarmé, then Paul Valéry, André Malraux, and Georges Bataille.

Baudelaire, His First Defender

Baudelaire no longer wrote about the Salons by the time Manet began to show his work. But he supported him in other ways, as can be seen in these excerpts from his letters.

I want to thank you for the pleasure you have given me in coming to the defense of my friend Edouard Manet, and in dealing him a little bit of justice. However, there are a few small points to straighten out in the opinions that you have published.

Manet, whom people think wild and insane, is simply a very straightforward, unaffected person, as reasonable as he can be but unfortunately touched by romanticism at birth.

The word "imitation" is unfair. Manet has never seen a Goya; Manet has never seen a Greco; Manet has never seen the Pourtalès Collection. This seems unbelievable to you, but it's true.

I have myself admired, in amazement, these mysterious coincidences.

At the time when we used to enjoy that wonderful Spanish museum, which the stupid French Republic in its excessive respect for private property gave back to the House of Orléans, Manet was a youngster serving in the navy. People have told him so much about his imitations of Goya that he is now trying to see some Goyas.

It is true that he has seen Velázquez, I know not where....

Do not be annoyed, but keep in some corner of your mind a kind thought for me. Every time you try to do a good deed for Manet, I shall thank you...

Baudelaire to Théophile Thoré
c. 20 June 1864

Manet's talent is strong and will endure. But his character is weak. He seems to me to be prostrated and stunned by the blow. What strikes me also is the joy of all those imbeciles who think he has lost.

Baudelaire to Champfleury
25 May 1865

Brilliant Faculties

When you see Manet, tell him this: that torment—whether it be great or small—that mockery, that insults, that injustice are excellent things, and that he should be ungrateful were he not thankful for injustice. I well know he will have some difficulty understanding my theory; painters always want immediate success. But really, Manet has such brilliant and facile ability that it would be unfortunate if he became discouraged. He will never be able to fill completely the gaps in his temperament. But he has a *temperament*, that's the important thing. And he does not seem to suspect that the greater the injustice, the better the situation—on condition that he does not lose his head. (You will know how to say this lightly, and without hurting him.)

Baudelaire to Mme. Paul Meurice
24 May 1865

Valéry, Manet, and Baudelaire

Even if he never met Manet, Paul Valéry heard a great deal about him: The poet had in fact married the niece of Berthe Morisot-Manet and lived in the family house surrounded by the work of her aunt and her brother-in-law, Manet. A great admirer of both the painter and Baudelaire, he sensed the affinity between the two men.

Manet, still seduced by the exotically picturesque, while given over to the

An etching and aquatint of Baudelaire (1867–8).

matador, the guitar and the mantilla, was already half conquered by objects closer to him, as well as by models in the street. This situation was to Baudelaire the very problem he himself had; that is, the critical state of an artist who is prey to rival temptations, and in addition to which, was capable of expressing himself admirably in several ways.

You only need to leaf through the slender collection of *The Flowers of Evil*, to observe the significant and concentrated diversity of theme among these poems, to associate them with the diversity of subjects in the body of Manet's work, and to conclude fairly easily that a true affinity of concerns existed between the poet and the painter.

A man who wrote *Benediction*, *Parisian Tableaux*, the *Jewels*, and the *Wine of the Ragpickers*, and the man who in turn painted *Christ with the Angels* and the *Olympia*, *Lola*, and *The Absinthe Drinker* are not without

some profound resemblance.

A few observations allow one to strengthen this relationship. Sprung from that old Parisian bourgeoisie, both of them showed that same rare refined elegance in their taste and their singular will for rigor in execution.

Moreover, they equally repulse those effects that do not emanate from a clear conscience and from the possession of their faculties in their crafts; it is in this that consists the *purity* in matter of painting and poetry. They wanted nothing to do with speculation over "sentiment" nor the introduction of "ideas" without knowledgeably and subtly mastering "sensation." They pursued, in summation, and reunited with the ultimate objective of their art, enchantment, a term that I use here with all its power.

Paul Valéry
Triumph of Manet
1932

Zola

Emile Zola was the most talented and the greatest journalistic supporter throughout Manet's career, notably in 1866 and 1867, when he discussed the Olympia. *But in the 1870s, the "Impressionist" direction adopted by the painter disappointed him. Still, he was happy that Manet never read his novel* The Masterpiece, *published in 1886, in which the failed painter is a mingling of Manet and Cézanne.*

He Sometimes Gets Off Course

He has been unable to work out his own methods; he remains an excitable student, seeing very accurately what takes place in nature, but not sure that he can definitively and fully transmit his impressions. Therefore when he starts out on his own path, you are not sure how he will reach the end of it or whether he will reach it at all. He works at random. When one of his paintings succeeds, then it is indeed extra-ordinary, absolutely truthful, and unusually skillful. But sometimes he makes mistakes, and then his paintings are uneven and incomplete. In short, during the past fifteen years there has not appeared another more individual artist. If the technical side of the matter were equal to the accuracy of his impressions, he would be a great painter of the second half of the nineteenth century.

Emile Zola
in *The Messenger of Europe*
Saint Petersburg, June 1879

"The Eye, a Hand"

That a tragic fate—aside from the fact that he was cheated of glory by Death, the universal conspirator—that a harsh and hostile destiny should have denied a man pleasure and grace disturbs me: not the vilification of the latest—and instinctive—reinventor of our great pictorial tradition, nor the fact of a merely posthumous gratitude. Yet amid the disappointments and vexations, behold the virile naïveté of a faun in putty-colored greatcoat, his thinning blond hair and beard going smartly gray. To all appearances a café wit, and elegant; yet in the studio, a demiurge flinging himself upon the canvas in frenzy, as if he had never painted before—what was once a precocious talent for unsettling us, here pursued with happy strokes of inspiration and sudden mitigations: a lesson to my daily attendance, a lesson that one must risk oneself entire and anew each time, a total virtuality even while remaining,

Manet's portrait of Edgar Allan Poe and the poster for "The Raven," which Mallarmé translated.

quite deliberately, oneself. How fervently he used to say, in those days, "The eye, a hand"—it all comes back to me now.

Manet's eye—the eye of generations of city-bred childhoods, when brought to bear, quite new, virginal, and abstract, on an object, on persons, sustained to the last the immediate freshness of the encounter; gripped in the talons of a glancing laugh, teasingly exorcising the exasperations of what would turn out to be the twentieth sitting. Manet's hand—its pressure registered as distinct and ready—expressed how mysteriously the limpidity of looking penetrated, in order to order, lively and laved, profound, intense, or obsessed by certain black contours, the masterpiece, new and French.

Stéphane Mallarmé
"Manet"
Divigations, 1896

An Art Historian's Point of View

Manet hardly considered himself a revolutionary and probably did not even want to be one. There was none of the provocative element in him which had always made Courbet the center of discussions; his independence was not an attitude chosen to force attention, it was the natural condition in which he lived and worked. Little did he expect that this independence might be considered a challenge by others and that he would have to fight in order to maintain his right to be himself. But he was ready to fight. He had been and still was of the opinion that the Salon was the natural place for an artist to introduce himself, yet this did not mean that he accepted the jury's decision. Somehow he hoped, as doubtless most of the others did, that

the public would be on his side and prove the jury wrong. There even seemed to be a vague possibility that a success of the Salon des Refusés might lead to the complete suppression of the jury, for which the realists and their friends had already fought for years….

Zacharie Astruc expressed himself more specifically about the rejected artists. For the duration of the exhibition he founded a daily paper, *Le Salon de 1863*, in which he had the courage to write: "Manet! One of the greatest artistic characters of the time! I would not say that he carries off the laurels in this Salon…but he is its brilliance, inspiration, powerful flavor, surprise. Manet's talent has a decisive side that startles; something trenchant, sober, and energetic, that reflects his nature, which is both reserved and exalted, and above all sensitive to intense impressions."

Of the three paintings exhibited by Manet, two derived their color accents from picturesque Spanish costumes; one was a portrait of his brother, *Young Man in the Costume of a Majo*; the other, *Mlle. V… in the Costume of an Espada*, had been posed for by his favorite model, Victorine Meurent. The third canvas, listed under the title *Le Bain*, was later to be called *Le Déjeuner sur l'Herbe*. It was this last picture that immediately attracted all visitors, the more so because the Emperor had pronounced it "immodest." Mr. Hamerton [an English art critic] agreed with the monarch when he wrote: "I ought not to omit a remarkable picture of the realist school, a translation of a thought of Giorgione into modern French. Giorgione had conceived the happy idea of a *fête champêtre* in which, although the gentlemen were dressed,

the ladies were not, but the doubtful morality of the picture is pardoned for the sake of its fine color.… Now some wretched Frenchman has translated this into modern French realism, on a much larger scale, and with the horrible modern French costume instead of the graceful Venetian one. Yes, there they are, under the trees, the principal lady, entirely undressed…another female in a chemise coming out of a little stream that runs hard by, and two Frenchmen in wide-awakes sitting on the very green grass with a stupid look of bliss. There are other pictures of the same class, which lead to the inference that the nude, when painted by vulgar men, is inevitably indecent."

As a matter of fact, the central group of Manet's *Déjeuner sur l'Herbe*, though superficially related to Giorgione, had been adapted from an engraving after Raphael. Indeed a curious lack of imagination repeatedly led Manet to "borrow" subjects from other artists. Many of his works, if not based directly on old masters, were at least inspired by remembrance (Manet had travelled extensively), by reproductions, prints, etc. Although Manet himself rarely made any allusions to his sources, he often used them with so little disguise that it would have been easy to identify them had anybody cared to do so. But in Manet's case the whole question seemed of little importance, since what mattered was not the subject but the way in which he treated it. He found in works of the past only compositional elements; he never copied, because only his inspiration, not his talent, needed an occasional guide. As Degas later explained it: "Manet drew inspiration from everywhere, from Monet, Pissarro, even from me. But with what

marvelous handling of the brush did he not make something new of it! He had no initiative… and did not do anything without thinking of Velázquez and Hals. When he painted a fingernail, he would remember that Hals never let the nails extend beyond the fingers themselves, and proceeded likewise. He felt only one ambition, to become famous and to earn

Manet's illustration for "The Raven."

indicating background details and of obtaining forms without the help of lines, by opposing colors or by sketching his contours, if necessary, with decisive brushstrokes in color (which helped to model volumes instead of limiting them), that were responsible for the almost universal disapproval he met.…

money. I told him to be satisfied with being appreciated by an elite; one who works with so much refinement cannot expect to be understood by the masses." Yet the irony of fate caused Manet to be attacked for the "vulgarity" of his inspiration, even in cases where he had derived his themes from the classic masters.

It may be doubted whether Manet's painting would have provoked such criticism had it not been painted in broad contrasts and frank oppositions, with a tendency to simplification. His "vulgarity," in the eyes of the public, lay probably even more in his execution than in his subject matter. It was his renunciation of the customary slick brushwork, his fashion of summarily

Compared with the prestige of ridicule obtained by Manet and Whistler, most of the other exhibitors at the Salon des Refusés fared rather well with the public and the reviewers. Pissarro even drew a few favorable lines from a renowned critic, who advised him, nevertheless, to be careful not to imitate Corot. Among the young painters outside the Academy, Manet's stature grew immensely through this exhibition so as to make him appear the leader of the new generation (Cézanne, Bazille, Zola were among those deeply impressed), and when Whistler and Fantin took a recent British acquaintance, the nineteen-year-old Swinburne, to the painter's studio, this visit became a

highlight of the latter's trip to Paris. "He [Manet] doubtless does not remember it," the poet wrote many years later to Mallarmé, "but for me, then very young and completely unknown…you may well believe it is a memory which will not easily be forgotten."

John Rewald
The History of Impressionism, 1946

The Representation of the World

It was said that Manet didn't know how to paint a centimeter of skin, and that the *Olympia* was drawn in steel wire; one forgot only that before wanting to "draw" *Olympia* or paint her skin, he first wanted to make paintings.…

The painting, whose background was a hole, became a surface, and this surface became not only its own design, but its only design. The most imperious sketches of Delacroix were still dramatizations; what Manet undertook in certain canvases was the representation of the world. For if it already happened that his brushwork took on this autonomy which ultimately would be vindicated, it was only in the service of a passion of which painting was only the means.… The objective of that keenness of vision is only a means, it's the transformation of things into a autonomous plastic universe, coherent and distinctive.…

What Manet brought, not in any way superior, but in being irreducibly different, was the green of the *Balcony*, the pink splotch of the gown in the *Olympia*, the patch of raspberry behind the black bodice of *Bar at the Folies-Bergére*.… It was tradition brought back to the pleasure of painting.

André Malraux,
Psychology of Art—The Imaginary Museum, 1947

Supreme Indifference

Manet's sober elegance, bared elegance, quickly attained a rectitude, not only in its indifference, but in the active sureness of how it knew to show indifference. The indifference of Manet is indifference supreme, which, while scandalizing, doesn't deign to know that it carries scandal within it.…

For often, indifference is a force; because a force, otherwise constrained, is liberated within indifference. Here Manet's joy in painting, which he took to the level of a passion, mixed with that divine indifference which opposed the mythological world where Raphael and Titian took delight. Here was the affirmation of a sober power which went along with a sober rejoicing in destruction. Manet attained the silence of freedom that his virtuosity gave him: at the same time it was the silence of rigorous destruction. The *Olympia* was the culmination of that elegance in that in the play of those rare colors there was the same intensity of the negation of an accepted world.…

We can discover in others as in Manet the transition in painting, of a language that tells, that is of an "imagined or real spectacle."… We cannot not see a glimmer appear in the painting of Chardin or of Delacroix, of Courbet or of Turner. Perhaps a little bit everywhere in painting…

But it is expressly to Manet that we first owe the birth of this painting with no other meaning than the art of painting which is "modern painting."

Georges Bataille
Birth of Modern Painting, 1955

Champfleury asked Manet to make a poster for his work *The Cats* (1868).

J. ROTHSCHILD, ÉDITEUR, 43, RUE S¹-ANDRÉ-DES-ARTS, PARIS

CHAMPFLEURY
LES CHATS

HISTOIRE – MŒURS – ANECDOTES

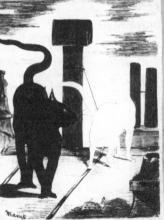

Manet

ILLUSTRÉ
PAR

E. Delacroix
Breughel
Viollet-le-Duc
—

ILLUSTRÉ
PAR

Ed. Manet
Ok'Saï
Mind, Ribot
—

UN VOLUME ORNÉ DE NOMBREUSES GRAVURES

 PRIX : **5** FRANCS

Paris. — Typ. Gaittet, rue du Jardinet, 1.

A Few Comments from Painters

Manet was a painter loved by other painters, first by his contemporaries Fantin-Latour and Degas, and then, in successive waves, by all the young artists who saw in him an example of freedom and modernity, from Monet and Cézanne to Matisse and Picasso. Picasso reinterpreted Le Déjeuner sur l'Herbe *in 1959–62 in a series of works where he showed himself to be both an iconoclast and an admirer, as Manet was in his time of Raphael and Titian.*

PORTRAIT DU TINTORET.

J'autorise M. Manet à reproduire ma binette, à condition qu'il ne la montrera à personne.

TINTORET.

Cézanne

What made Manet a real forerunner was that he brought a simple formula to a period when officially accepted art was nothing but bombast and convention.

> Recalled by Ambroise Vollard, 1924

Degas

Courbet said he's never seen any angels and so could not know if they have backsides, and furthermore, given their size, it is unlikely that the wings that Manet put on them could support them. But I don't give a damn about all that, because there is real drawing in this *Christ with the Angels!* And the transparent quality of the paint! Oh! the pig!

ME—Ingres never worked outdoors, but didn't Manet work outdoors?

DEGAS (annoyed)—Don't say that word "outdoors" in front of me anymore. Poor Manet! Having painted the *Maximilian*, the *Christ with the Angels*, and all that he did until 1875, and then to let go of his magnificent "eye" to paint *The Laundry!*…

> Recalled by Ambroise Vollard, 1924

Pissarro

Manet was greater than us; he was able to make light out of black.

> Recalled by Ambroise Vollard, 1924

Signac

What a painter! He has everything, an intelligent mind, an impeccable eye, and what a hand!

> From *Journal,* in *La Gazette des Beaux-Arts,* 1949

The caption under this caricature by Randon reads: "I authorize M. Manet to reproduce my face, on the condition that he shows it to no one. Tintoretto"

Portraits of Manet by Degas (1866–8) and Monet by Manet (1879–80, below).

Gauguin

He once told me, having seen a work of mine (when I was just beginning), that it was very good; I retorted out of respect for his mastery: "I am only an amateur." At the time I was working as a stockbroker and was studying art only at night and on holidays.

"No way," said Manet.... "The only amateurs are those who do bad painting." That was sweet to hear.

Before and After, 1923

Jacques-Emile Blanche

There aren't two paintings in his entire body of work that weren't inspired by another painting, antique or modern.... There was no one who "plagiarized" more and no one who was more original.... Always and everywhere, the *touch* was Manet's, his paint was unique; his awkwardness, his simultaneous precision and resolution were his alone. It's well made even in the apparent carelessness. There is a fullness in the simplified and awkward drawing, there is distortion in the feeling of grandeur. His flat modeling eliminates certain planes, gives a unique quality to his still life, to objects. Do you remember the *Ham* on the silver platter, the *Bunch of Asparagus.* No one ever painted like that before him....

A painter of great craftsmanship can be inspired, must be inspired by what he loves and re-create it in his own way. There are artists devoid of inventiveness and personality, whose style suggests no resemblance to any other style, and who are nonetheless insipid and of no interest. Originality resides less in the conception than in the execution. The means are everything in painting.

Remarks of a Painter from David to Degas, 1919

Matisse

The Orientals used black as a color, notably the Japanese in their prints. Nearer home, in a certain painting by Manet (*The Luncheon*) I recall that the black velvet jacket of the young man in a straw hat is a bold and luminous black....

Bertall's 1869 cartoon of *The Luncheon* and Picasso's 1962 drawing inspired by *Le Déjeuner sur l'Herbe*.

He was the first *to act by reflex*, thus simplifying the painter's métier.... Manet was as direct as one could be....

A great painter is one who finds lasting personal signs for the expression of his vision. Manet found his.

L'Intransigeant
25 January 1932

Picasso

"When I see *Le Déjeuner sur l'Herbe*, I say to myself: Sorrows are for later."

Said in 1932, cited in
Bonjour M. Manet, 1983

One summer day at [Picasso's home he] told us a major piece of news: *Lola de Valence* had just arrived in Nice.

If it had to do with a Lola in the flesh, an eminent personality, a Moon-man who had just landed on the airfield, of Sabartès or even of the children, Picasso would have spoken no differently.

Lola de Valence had arrived in Nice with a few other canvases from the same period, for an exhibition in the city's museum....

We spoke only of *Lola de Valence*, the beautiful, the magnificent. Picasso and Pignon were in the studio. Indeed, only Manet existed. They recited all of his canvases. They spoke about them for an hour.

They leafed through a book where there were Manets, saying many things and raving about them. Only Cézanne and Van Gogh left the arena in triumph. All the rest is crap.... And what a marvelous canvas.

Cited by H. Parmelin
Picasso on the Beach, 1959

Further Reading

MONOGRAPHS AND
GENERAL WORKS

Bataille, Georges,
Manet, trans. Austryn
Wainhouse and James
Emmons, rev. ed.,
Skira/Rizzoli, New York,
1983

Bazire, Edmond, *Manet*,
A. Quentin, Paris, 1884

Blanche, Jacques-Emile,
Manet, Dodd, Mead,
New York, 1925

Cachin, Françoise,
Manet, Chêne, Paris,
1990

Distel, Anne, *Les
Collectionneurs
d'Impressionnistes*,
Bibliothèque des Arts,
Paris, 1989

Duret, Théodore, *Manet*,
trans. J. E. Crawford
Flitch, Crown, New
York, 1906

———, *Manet*, Crown,
1937

Gordon, Robert, and
Andrew Forge, *The Last
Flowers of Manet*, Harry
N. Abrams, New York,
1986

Hamilton, George
Heard, *Manet and His
Critics*, Yale University
Press, New Haven, 1954

Hanson, Anne Coffin,
*Manet and the Modern
Tradition*, Yale University
Press, New Haven, 1977

Hofmann, Werner,
*Nana, Mythos und
Wirklichkeit*, M. Dumont
Schauberg, Cologne, 1973

Mallarmé, Stéphane,
"The Impressionists and
Edouard Manet," *Art
Monthly Review*, 30
September 1876,
pp. 117–22

Moore, George,
*Confessions of a Young
Man*, McGill–Queens
University Press,
Montreal, 1972

Moreau-Nélaton,
Etienne, *Manet Raconté
par Lui-Même*, H.
Laurens, Paris, 1926

Proust, Antonin,
"Edouard Manet,
Souvenirs," *La Revue
Blanche*, February–May
1897 (revised in
L'Echoppe, 1988)

Reff, Theodore, *Manet:
Olympia*, Allen Lane,
New York, 1976

Rewald, John, *The
History of Impressionism*,
4th ed., Museum of
Modern Art, New York,
1973

Schneider, Pierre, *The
World of Manet
1832–1883*, Time-Life,
New York, 1968

Tabarant, Adolphe,
Manet et Ses Oeuvres,
Gallimard, Paris, 1947

Vollard, Ambroise, *En
Ecoutant Parler Cézanne,
Degas, Renoir*, Grasset,
Paris, 1938

Wilson, Juliet Bareau,
Manet by Himself,
Macdonald, London,
1991

Zola, Emile, "Une
Nouvelle Manière en
Peinture, Edouard
Manet," *Revue du
XIXeme Siècle*, 1 January
1867, and *E. Manet, Etude
Biographique et Critique*,
E. Dentu, Paris, 1867

CATALOGUES OF WORKS
AND EXHIBITIONS

Cachin, Françoise, and
Charles S. Moffett in
collaboration with
Michel Melot, *Manet
1832–1883*, Metropolitan
Museum of Art/Harry N.
Abrams, New York, 1983

Guérin, Marcel, *L'Oeuvre
Gravé de Manet*, Paris,
1944

Hanson, Anne Coffin,
*Edouard Manet 1832–
1883*, Philadelphia
Museum of Art,
Philadelphia, 1966

Orienti, Sandra, *The
Complete Paintings of
Manet*, Harry N.
Abrams, New York, 1967

Rouart, Denis, and
Daniel Wildenstein,
*Edouard Manet,
Catalogue Raisonné*,
Bibliothèque des Arts,
Lausanne, 1975

Reff, Theodore, *Manet
and Modern Paris*,
National Gallery of Art,
Washington, D.C., 1982

Tabarant, Adolphe,
*Manet; Histoire
Catalographique*, Editions
Montaigne, Paris, 1931

Valéry, Paul, "Triomphe
de Manet," in *Manet*,
exhibition catalogue,
Musées Nationaux, Paris,
1932

List of Museums

Where can you see Manet's greatest works? While most belong to a few select institutions (in New York, London, Paris, Chicago, and Philadelphia), others are scattered in museums around the world.

ARGENTINA
Buenos Aires
Museo Nacional de Bellas Artes: *The Surprised Nymph*

BELGIUM
Tournai
Musée des Beaux-Arts: *Argenteuil, At Père Lathuille's Restaurant*

BRAZIL
São Paulo
Museu de Arte Moderna: *Bathers in the Seine, The Artist*

FRANCE
Avignon
Musée Calvet: *Guitar and Hat*

Dijon
Musée des Beaux-Arts: *Méry Laurent in the Black Hat*

Le Havre
Musée du Havre: *Boats at Sea, Sunset*

Nancy
Musée des Beaux-Arts: *Autumn*

Paris
Musée d'Orsay: *Portrait of M. and Mme. Auguste Manet, Lola de Valence, Le Déjeuner sur l'Herbe, Olympia, Peonies in a Vase on a Stand, Branch of White Peonies with Pruning Shears, Peony Stems and Pruning Shears, Fruit on a Table, Bullfight, The Fifer, Reading, Portrait of Emile Zola, Mme. Manet at the Piano, The Balcony, Moonlight over Boulogne Harbor, The Blonde with Bare Breasts, On the Beach, Lady with the Fans/ Portrait of Nina de Callias, Portrait of Stéphane Mallarmé, Girl Serving Beer, Portrait of Clemenceau, Asparagus, Pinks and Clematis in a Crystal Vase*

Musée du Petit Palais: *Portrait of Théodore Duret*

GERMANY
Berlin
Staatliche Museen: *The House at Rueil, In the Conservatory*

Bremen
Kunsthalle: *Portrait of Zacharie Astruc*

Cologne
Wallraf-Richartz-Museum: *Bunch of Asparagus*

Frankfurt
Städelsches Kunstinstitut: *Croquet Party in Paris*

Hamburg
Kunsthalle: *Nana, Portrait of M. Henri Rochefort*

Mannheim
Städtische Kunsthalle: *The Execution of Maximilian*

Munich
Neue Pinakothek: *Claude Monet in His Studio, The Luncheon*

GREAT BRITAIN
Glasgow, Scotland
Art Gallery and Museum: *Ham*

London
Courtauld Institute Galleries: *A Bar at the Folies-Bergère*

National Gallery: *Music in the Tuileries, Corner in a Café-Concert, Eva Gonzalès*

HUNGARY
Budapest
Szépmüvészeti Múzeum: *Baudelaire's Mistress, Reclining*

NORWAY
Oslo
Nasjonalgalleriet: *L'Exposition Universelle*

PORTUGAL
Lisbon
Museu Calouste Gulbenkian: *Soap Bubbles, Child with Cherries*

SWITZERLAND
Winterthur
Oskar Reinhart Collection: *At the Café*

Zurich
Fondation Bührle: *The Port of Bordeaux, Suicide, Young Woman in Oriental Costume*

UNITED STATES
CALIFORNIA
Malibu
J. Paul Getty Museum: *The Rue Mosnier with Flags*

San Francisco
Palace of the Legion of Honor: *The Milliner*

CONNECTICUT
Farmington
Hillstead: *The Guitar-Player, La Posada*

New Haven
Yale University Art Gallery: *Young Woman Reclining in Spanish Costume*

DISTRICT OF COLUMBIA
Washington
National Gallery of Art: *Masked Ball at the Opéra, The Plum, The Railroad, The Dead Man, The Old Musician, Still Life with Melon and Peaches*

Phillips Collection: *The Spanish Ballet*

ILLINOIS
Chicago
Art Institute: *Bullfight, Races at Longchamp, Still Life with Fish, Jesus Mocked by the Soldiers, Steamboat, Seascape, The Philosopher, Reader at the Brasserie*

MARYLAND
Baltimore
Walters Art Gallery: *Café-Concert*

MASSACHUSETTS
Boston
Museum of Fine Arts: *The Street Singer, The Music Lesson, Portrait of Victorine Meurent*

Cambridge
Fogg Art Museum: *Skating*

List of Illustrations

Key: **a**=above; **b**=below; **c**=center; **l**=left; **r**=right

All works (except photographs) are by Edouard Manet unless otherwise noted.

Front cover The Balcony (detail), 1868–9. Oil on canvas, 66 1/2 x 49 1/4" (169 x 125 cm). Musée d'Orsay, Paris, Gustave Caillebotte legacy
Spine The Fifer (detail), 1866. Oil on canvas, 63 x 38 1/2" (160 x 98 cm). Musée d'Orsay, Paris
Back cover On the Beach, 1873. Oil on canvas, 23 1/2 x 28 7/8" (59.6 x 73.2 cm). Musée d'Orsay, Paris
1 *Portrait of Victorine Meurent* (detail), 1862. Oil on canvas, 17 x 17" (43 x 43 cm). Museum of Fine Arts, Boston, gift of Richard C. Paine in memory of his father, Robert Treat Paine II
2 *The Street Singer* (detail), 1862. Oil on canvas, 69 x 42 3/4" (175.2 x 108.5 cm). Museum of Fine Arts, Boston, legacy of Sarah Choate Sears in memory of her husband, Joshua Montgomery Sears

3 *Mlle. V... in the Costume of an Espada* (detail), 1862. Oil on canvas, 65 x 50 1/4" (165.1 x 127.6 cm). The Metropolitan Museum of Art, New York, gift of Mrs. Henry O. Havemeyer
4 *Le Déjeuner sur l'Herbe* (detail), 1863. Oil on canvas, 82 x 104" (208 x 264 cm). Musée d'Orsay, Paris, gift of Etienne Moreau-Nélaton
5 *Olympia* (detail), 1863. Oil on canvas, 51 3/8 x 74 3/4" (130.5 x 190 cm). Musée d'Orsay, Paris
6 *Woman with a Parrot* (detail), 1866. Oil on canvas, 72 7/8 x 50 5/8" (185.1 x 128.6 cm). The Metropolitan Museum of Art, New York, gift of Erwin Davis
7 *The Railroad* (detail), 1872–3, Oil on canvas, 36 1/2 x 45" (93 x 114 cm). National Gallery of Art, Washington, D.C., gift of Horace Havemeyer
9 *Lemon*, 1880–1. Oil on canvas, 5 1/2 x 8 1/4" (14 x 21 cm). Musée d'Orsay, Paris
10 *Portrait of M. and Mme. Auguste Manet* (detail), 1860. Oil on canvas, 44 x 35 3/4"

(111.5 x 91 cm). Musée d'Orsay, Paris
11 *Maternity*. Drawing in red chalk after *The Birth of the Virgin* by Andrea del Sarto. Drawings Department, Musée du Louvre, Paris
12 Captain Edouard Fournier, Manet's uncle. Photograph. Bibliothèque Nationale, Paris
12–3 Manet as a child. Photograph. Private collection
13a *Portrait of M. and Mme. Auguste Manet*, 1860. Oil on canvas, 44 x 35 3/4" (111.5 x 91 cm). Musée d'Orsay, Paris
13b Facade of Manet's birthplace, No. 5 Rue Bonaparte, Paris. Photograph
14 *Self-portrait of Tintoretto*, 1854. Copy after Tintoretto's 1588 painting in the Musée du Louvre. Oil on canvas, 24 1/2 x 20 1/2" (61 x 51 cm). Musée des Beaux-Arts, Dijon
14–5 Facade of the Collège Rollin on the Avenue Trudaine. Photograph. Musée Carnavalet, Paris
15 Artist unknown. Copyists in the main gallery of the Musée du

Louvre. Lithograph, 1880. Bibliothèque des Arts Décoratifs, Paris
16, 17a, and 17b Portions of two letters Manet sent to his mother from Rio de Janeiro in early 1849. Private collection
16–7 Guanabara Bay. Photograph. Collection Sirot-Angel
18a Thomas Couture. *Romans of the Decadence*, 1847. Oil on canvas. Musée du Louvre, Paris
18c Thomas Couture. Photograph
18b Thomas Couture's signature at the bottom of a note addressed to Manet. Bibliothèque d'Art et d'Archéologie, Paris
19l Title page of *Méthode et Entretiens d'Atelier* (*Technique and Discussions in the Studio*) by Thomas Couture, 1867. Bibliothèque Nationale, Paris
19r Pencil drawing of the back of a draped nude, after a figure in Andrea del Sarto's c. 1510 painting *Baptism of Christ* in the Scalzo cloister in Florence. Drawings Department, Musée du Louvre, Paris

The Parisian Woman, a lithograph of Nina de Callias.

Two of Manet's drawings: *Woman Standing on the Beach* and *Cats* (opposite).

Index

T*he Bear Trainer* (1862). Brush and brown wash over pencil.

Acknowledgments

The publishers would like to thank Mme. Montalant of the Galerie Hopkins-Thomas and M. Yves Rouart for their help in the creation of this book.

Photograph Credits

AKG 27ar, 28a, 41l, 110l, 110r, 110–1. All rights reserved 12–3, 161l. Archives Albert Skira 57. Archives Durand-Ruel, Paris 118. Archives Roger-Viollet, Paris 13b. Artephot/Artothek, Paris 86–7. Artephot/Bridgeman, Paris 116r, 117l, 121. Artephot/Held, Paris 75a, 75b, 76a, 94a, 108a, 122r, 128. Artephot/Oroñoz, Paris 84. Artephot/Roland, Paris 21b. The Art Institute of Chicago 76–7, 82b. Artothek, Peissenberg 72a. Atelier Jean-Loup Charmet, Paris 15, 56–7, 76b, 86b, 89b. The Barnes Foundation, Merion, Pennsylvania 80–1, 104. Bibliothèque d'Art et d'Archéologie, Paris 18b, 38–9, 56a, 64a, 103, 117r, 129, 144, 161r. Bibliothèque Nationale, Paris 12, 19r, 20b, 21a, 25, 27al, 27b, 32, 35r, 35c, 39, 40l, 47, 48, 49, 59, 60–1, 68r, 77, 82a, 83, 87b, 89a, 91, 92a, 94–5, 98, 100, 105, 122l, 132, 137l, 137r, 138–9, 140a, 140b, 146, 153, 155l, 155r, 157, 159, 160, 162, 169, 173. Caisse Nationale des Monuments Historiques et des Sites, Paris 34l, 34r, 35l, 107. Collection Sirot/Angel, Paris 18c, 23a, 28bl, 28br, 68l, 85, 86a, 87a, 116l, 124a, 130, 135. Courtauld Institute Galleries, London 124b, 125, 126. Fogg Art Museum, Cambridge, Massachusetts 93a, 120. Galerie Hopkins-Thomas 72br. Giraudon 23b, 26, 56b, 90, 93b, 94c, 101, 123. J. Paul Getty Museum, Malibu 96–7, 97. Kunsthalle Bremen 71. Metropolitan Museum of Art, New York 3, 6, 31, 40r, 44–5, 50, 51, 63, 70r, 95, 96b, 109, 122–3. Musée Boymans, Van Beuningen, Rotterdam 41r. Musée des Beaux-Arts, Dijon 14, 115l, 115ar, 115b. Musée Marmottan, Paris 16–7. Museo Nacional de las Bellas Artes, Buenos Aires 37l, 37r. Museum of Art, Philadelphia 78–9, 88, 99, 112l. Museum of Fine Arts, Boston 1, 2, 42b, 42–3, 43b, 44, 84–5. National Gallery of Art, Washington 7, 42ar, 64–5a, 102–3, 106, 111. National Gallery, London 24, 34–5, 118–9, 150. Phototèque des Musées de la Ville de Paris 14–5, 32–3. Réunion des Musées Nationaux, Paris front cover, spine, back cover, 4, 5, 9, 10, 11, 13a, 18a, 19l, 20a, 22, 22–3, 29, 30, 33, 36al, 36ar, 36c, 36b, 38, 42al, 43a, 46, 48–9, 52–3, 54–5, 58–9, 61, 62, 64c, 64–5b, 66, 67, 69l, 69r, 70l, 72bl, 73l, 73r, 74, 92b, 96l, 96r, 100–1, 104–5, 108b, 112r, 113l, 113r, 114a, 114l, 114–5, 127, 136, 141, 143, 148, 149, 151, 162–3, 170, 171

Text Credits

Grateful acknowledgment is made for use of material from the following: Françoise Cachin and Charles S. Moffett in collaboration with Michel Melot, *Manet, 1832–1883*, © Editions de la Réunion des Musées Nationaux, Paris 1983. © 1983 by The Metropolitan Museum of Art, New York. *Manet, 1832–1883*, The Metropolitan Museum of Art. Reprinted with permission (pp. 149–150: Fervacques, from "Between the"); Théodore Duret, *Manet*, translated by J. E. Crawford Flitch, Crown Publishers, New York, 1937 (pp. 131–2); Robert Gordon and Andrew Forge, *The Last Flowers of Manet*, translations by Richard Howard, Harry N. Abrams, Inc., 1986 (pp. 130–1: Proust, first two paragraphs; 142: Jeanniot; 154–5: Mallarmé); George Heard Hamilton, *Manet and His Critics*, Yale University Press, 1954. Copyright 1954 by Yale University Press. Used by permission of the publisher (pp. 133: Morisot; 140–2: Manet's preface; 145: Gautier; 145: Saint-Victor; 145–6: Zola, except last paragraph; 148–9: Fervacques, through "famous Mürr" only; 152: Baudelaire to Thoré; 153: Baudelaire to Mme. Meurice; 154: Zola); George Moore, *Confessions of a Young Man*, edited by Susan Dick, McGill-Queen's University Press, 1972 (originally published in 1888) (p. 133); John Rewald, *The History of Impressionism*, 4th revised edition. The Museum of Modern Art, New York. Used with permissions of the publisher and Sabine Rewald, executor of the Estate of John Rewald (pp. 155–8)

Formerly the director of the Musée d'Orsay in Paris,
Françoise Cachin now heads the French Musées Nationaux.
She has organized many exhibitions, including one on Italian
Futurism (1973), "Manet" (1983), "Gauguin" (1988), "Seurat"
(1991), and "The Painters' Europe" (1993). She is the author
of numerous catalogues and other works on Gauguin, Signac,
Manet, and the monotypes of Degas and is the author of
Gauguin: The Quest for Paradise in the Discoveries series.

For Charlotte

Translated from the French by Rachel Kaplan

Editors: Jennifer Stockman and Sharon AvRutick
Typographic Designer: Elissa Ichiyasu
Design Supervisor: Miko McGinty
Assistant Designer: Tina Thompson
Text Permissions: Neil Ryder Hoos

Library of Congress Catalog Card Number: 94–77941

ISBN 0–8109–2892–2